IMAGES
of America

THE POLISH COMMUNITY
OF CHICOPEE

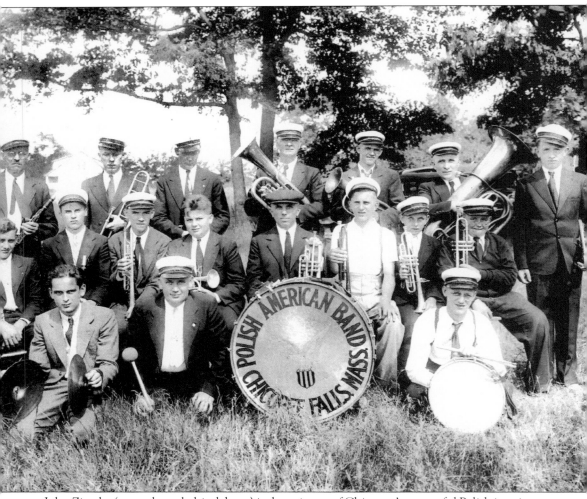

John Ziemba (second row, behind drum) is the epitome of Chicopee's successful Polish immigrant. He arrived alone at the age of 11. In his teens, he organized an orchestra and opened his own ice-cream parlor. He operated a successful dry goods business at 39 Grove Street. When the landlord raised the rent, Ziemba constructed his own building on Church Street. The Ziembas taught music to each of their seven children. The family included a teacher, two school principals, a medical doctor, and a mayor of Chicopee.

IMAGES
of America

THE POLISH COMMUNITY
OF CHICOPEE

Stephen R. Jendrysik

ARCADIA
PUBLISHING

Published by Arcadia Publishing
Charleston, South Carolina

Printed in the United States of America

Library of Congress Catalog Card Number: 2005927376

For all general information contact Arcadia Publishing at:
Telephone 843-853-2070
Fax 843-853-0044
E-mail sales@arcadiapublishing.com
For customer service and orders:
Toll-Free 1-888-313-2665

Visit us on the Internet at www.arcadiapublishing.com

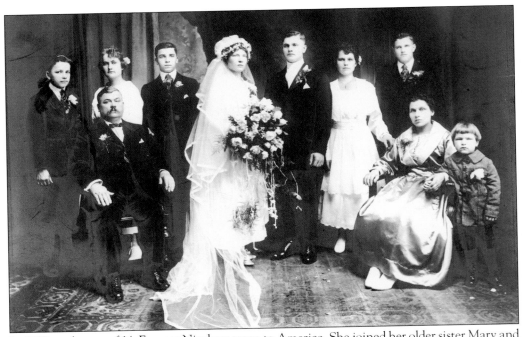

In 1910, at the age of 14, Frances Nieckarz came to America. She joined her older sister Mary and obtained employment in the Dwight Mills. Nine years later, she married a Polish immigrant who had worked briefly in a Pennsylvania coal mine. Apparently it was love at first sight. Frances told her daughters that the first time she saw the broad-shouldered, ruggedly handsome Leon Ciszek, he was walking down the street in his undershirt.

CONTENTS

ACKNOWLEDGMENTS

In 1953, I was in the eighth grade at the St. Stanislaus Parochial School. The parish archives were located in an unused classroom on the third floor. Father Eugene had given us the keys to the room. We were looking for some missing basketball uniforms. When we failed to return, he came looking for us. He found us immersed in the stacks of old pictures that filled the room. These were the documents of a Polish American success story, the treasured memorabilia of an immigrant church. Unfortunately, in 1973, long before I could write the book, the parish school burned to the ground.

In 1991, Dr. Gladys Midura wrote a definitive church history on the 100th anniversary of the founding of St. Stanislaus Parish. Her scholarly research really provided the groundwork for the preparation of *The Polish Community of Chicopee*. Since the outset, she has been entirely supportive of my efforts. She even volunteered to proofread the final manuscript. Dr. Midura's suggestions and comments were extremely helpful and most appreciated. Additional technical assistance was provided by Dolores Borowiec, Dr. Mark Jendrysik, Dr. John Kozikowski, and Sylvia Knowles.

For willingly sharing their family pictures, I am grateful to Thomas Bardon, Michael Baron, Olen and Jane Bielski, Stella Boleski, Robert Federowicz, Thomas Fournier, Alice Grabiec, Jane Janik, Anne Jendrysik, Florence Jendrysik, Chester Kobierski, John Krzeminski, Alice Pasterczyk, Joseph Kozikowski, James Lynch, the Marczak family, Alice Murphy, Joseph Partyka, Max Partyka, Joseph Pasternak, Alfred Pinciak, Frank Robak, Stanley Stec, Ann Szetela, Frank Tabot, Mary Wnuk, Walter Wrzesien, and Joanne Zaskey.

For allowing the use of materials from their archives, I thank the Basilica of St. Stanislaus, the Chicopee Historical Society, the Chicopee Public Library, the Connecticut Valley Historical Museum, the Edward Bellamy Memorial Association, the Holy Mother of the Rosary Church, the Polish Center for Discovery and Learning at Elms College, the Polish Genealogical Society of Massachusetts, the Polish National Credit Union, the Kosciuszko Foundation New England Chapter, and the St. Anthony of Padua Parish.

I also wish to thank the many people who contributed photographs and memories that, for reasons of space, I was unable to include in this book. I wish I could have included them all.

INTRODUCTION

The two giant cotton mills of Chicopee, Massachusetts, were booming in the 1880s. Unskilled laborers were needed at the Chicopee Manufacturing Company in Chicopee Falls and the Dwight Company in Chicopee Center. The Protestant Yankee and the first-generation Irish immigrants were attracted to better paying jobs in public service and skilled manufacturing. French Canadians were taking machinist jobs at J. Stevens Arms, Belcher and Taylor Agricultural Tool Company, the Overman Bicycle Manufacturing Company, and A. G. Spalding Brothers (the sporting goods manufacturer). The immigrants from Canada were sought after in lumber and home construction industries.

The majority of Austrian Poles who came to Chicopee were teenagers. By and large, they were penniless and uneducated. The males were avoiding military service. These young men and women were fleeing from the poorest province of the Austro-Hungarian Empire. Galicia, in southeastern Poland, was an agriculturally depressed region with a serious overpopulation problem. Considerable historic evidence implies that the youngsters planned to make some money and return to the homeland. Immigration statistics indicate that almost half of all the immigrants from eastern Europe opted to return to their homeland before 1914. Immigrants who were in their twenties, many with wives and families, did return to Europe. For the most part, the great majority of Chicopee's immigrant teens never looked back.

On October 28, 1886, Pres. Grover Cleveland dedicated the Statue of Liberty on Bedloe's Island in New York harbor's ship channel. In 1903, a poem by Emma Lazarus was inscribed on a tablet in the pedestal of the statue. For millions of immigrants, their first sighting was of a New York City skyline and the world's largest statue. Described as the "Mother of Exiles," she was a mighty woman with a torch. Her message was not lost on the hundreds of young Chicopee Poles who entered America via Ellis Island. The majestic lady in the harbor had lifted her lamp beside the golden door.

Poland

Gdańsk

Koszalin

Olsztyn

Szczecin

Białystok

Bydgoszcz

Poznań

WARSZAWA

Zielona Góra

Łódź

Lublin

Wrocław

Kielce

Opole

Katowice

Kraków • Tarnow • Rzeszów

Frysztak

Roznov • Gorlice

Jordanow

Nowy Targ

St. Stanislaus Parish historian Dr. Gladys Midura writes, "The majority of Poles who settled in Chicopee traced their roots to the southern portion of the Polish Nation, which had been annexed by Austria; it was commonly referred to as Galicia." The Austro-Hungarian Empire allowed the Poles to worship in their own churches and to use the Polish language in homes, schools, and places of worship. Records in Chicopee indicate that Austria, Prussia, and Germany are listed as places of birth for the immigrant Poles. In 1880, the entire country was under some form of foreign domination. Poles from Prussia and Russia found their way to Chicopee, but in smaller numbers. Between 1880 and 1914, the Polish newcomers could trace their roots to all of the various sections of Poland.

8

One

ARRIVAL
1880–1900

The first group of immigrant Poles arrived in Chicopee in 1880. Published accounts of their arrival have implied that their coming was accidental. But that year, whether by accident or by design, a small group of Polish immigrants found themselves at a railroad depot in Chicopee's Market Square.

St. Stanislaus Parish historian Dr. Gladys Midura writes, "Unable to ask for help because of language differences, these strangers were at a loss until Father Patrick Healey, Pastor of the Holy Name of Jesus arrived at the station and noticed their predicament. Father Healey was known for his humanitarianism and compassion for those in need, and he soon found the immigrants lodging in one of the town's boarding houses."

The first small group of immigrants was from the Austrian-held territory of Galicia. Most Polish immigrants came from the countryside. They were not a homogeneous mass of rural cultivators but were divided into small farmers, skilled artisans, agricultural day laborers, and servants. Father Healey would help them obtain employment in the vast Dwight Textile Mills. It would be their first introduction to the Industrial Revolution.

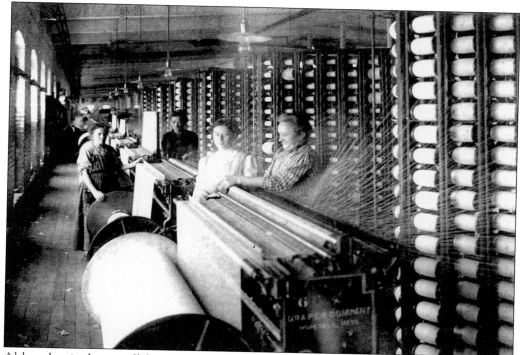

Although raised on small farms in Galicia and possessing no industrial experience whatsoever, the young Poles slowly adjusted to their new jobs in Chicopee's cotton mills. They worked long hours from dawn to dusk. For their efforts they received $2 a day.

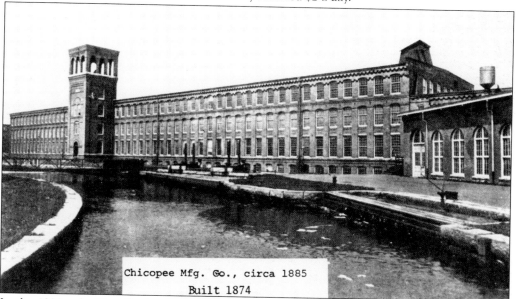

Chicopee Mfg. Co., circa 1885
Built 1874

In the 1880s, the New England textile industry was prospering with predominately immigrant labor. The Polish newcomers who worked at the Chicopee Manufacturing Company in Chicopee Falls managed to save a small portion of their meager wages. They would use the money to pay passage to this country for their relatives and friends.

CHICOPEE.
MASS.

In 1885, according to the town census, 205 Poles resided in Chicopee. They lived in the west end of town. Most had migrated from East Galicia. Many accepted factory labor as a short-term means to earn money. Considerable evidence suggests that their long-term goals were to return to Poland and buy their own land.

Father Healey welcomed the newcomers to his church. Reports indicate that the newly settled Poles were also accepted at the Assumption of the Blessed Virgin Mary, a French Canadian church on Front Street. In Chicopee Falls, a small number worshiped at St. Patrick's Church on Sheridan Street. The majority joined the Holy Name of Jesus Church on South Street.

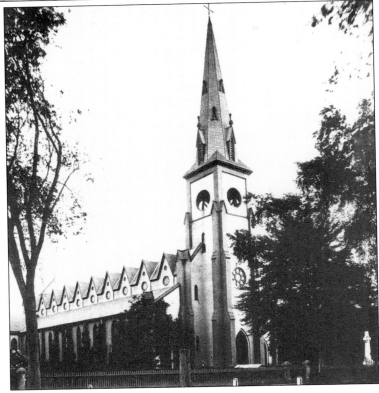

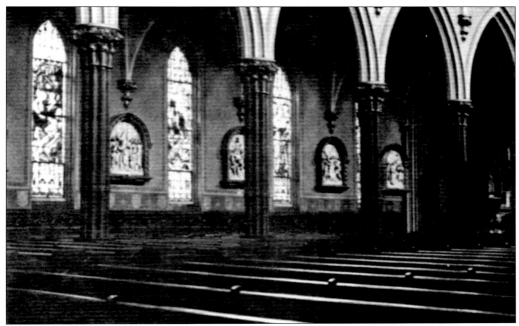

St. Stanislaus Church historian Dr. Gladys Midura reports that during the years of 1888 through 1890, about 30 percent of the baptisms recorded in the registers of the Holy Name Church were those of Polish infants. She indicates that the marriage rolls at Holy Name during those years show that more than half of the marriages listed were between Poles.

St. Stanislaus (1030–1079), bishop and martyr, had long been a symbol of Poland's Catholicism and nationhood. In 1888, the young Polish community in Chicopee began to formulate plans for the founding of a Polish church. The first step in the process was the establishment of the St. Stanislaus Bishop and Martyr Society.

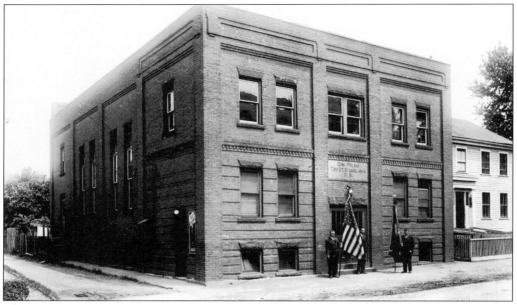

The primary purpose of the St. Stanislaus Fraternal and Benevolent Society was to provide sickness and death benefits for members through a low-cost insurance plan and to support worthy charitable causes. The newly formed organizational effort would set the wheels in motion for a Polish Roman Catholic church in Chicopee.

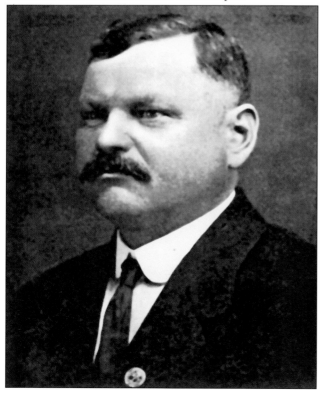

Francisek Jaworek was one of the founders of the new society who met at the home of president Wojciech Tulega. There, plans were made for the founding of St. Stanislaus Bishop and Martyr Church. At that initial meeting, the members made a commitment to provide financial backing for the proposed church.

In addition to the society's regular dues, it was decided that each member would be taxed 25¢ a month. The monthly tax was collected for the express purpose of raising funds for the new church that they hoped to build. Piot Oparowski became the chairperson; other members of the committee were president Wojciech (Albert) Tuleja, Jacob Sitnik, and Rev. Francis Chalupka.

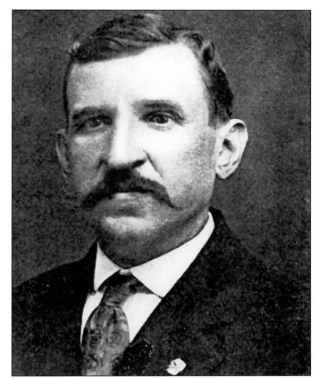

Rev. Francis Chalupka was born in Galicia. He completed his classical studies in Poland and in 1885 emigrated to the United States. He studied theology at St. Mary's Seminary in Baltimore, Maryland. He was ordained by Bishop Patrick O'Reilly in St. Michael's Cathedral in Springfield, Massachusetts, on May 20, 1888. He became the first priest of Polish descent to be ordained in Hampden County.

15

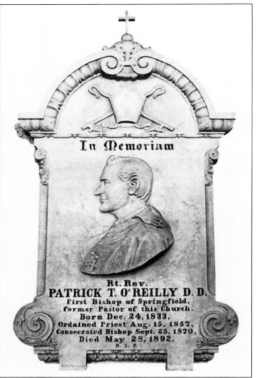

In Memoriam

Rt. Rev.
PATRICK T. O'REILLY D.D.
First Bishop of Springfield,
former Pastor of this Church.
Born Dec. 24, 1833,
Ordained Priest Aug. 15, 1857,
Consecrated Bishop Sept. 25, 1870,
Died May 28, 1892.
R. I. P.

In 1890, the church building committee met with Bishop Patrick O'Reilly and received his blessings for the establishment of a Polish Catholic church in Chicopee. At that time, the bishop named Father Chalupka as the group's spiritual advisor responsible for the organization of the new parish.

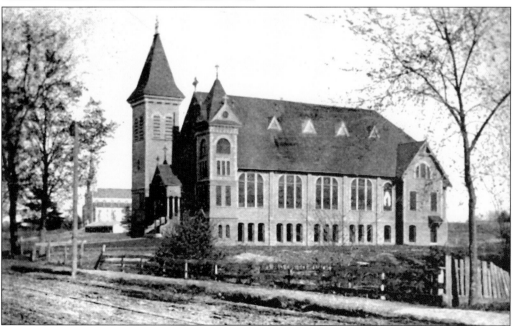

In a short time, $2,000 was collected to purchase a parcel of land from Chicopee real estate agent Maurice Granfield. The site on Front Street was ideal, located halfway between Chicopee Center and Chicopee Falls, the two areas where most of the Poles lived.

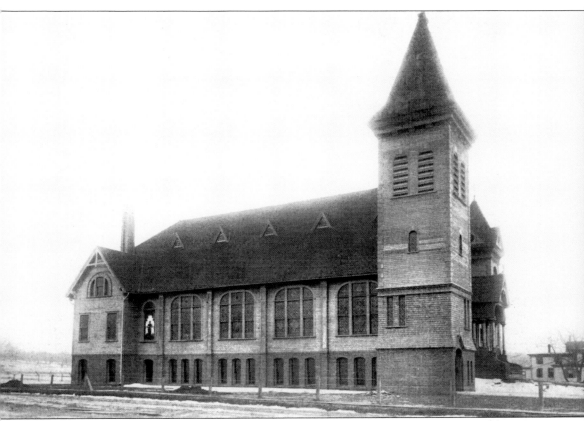

On December 25, 1891, Rev. Francis Chalupka celebrated a midnight mass in the new and as yet unfinished church. It had taken only 12 years for the immigrant Poles to realize the goal of building their own church. The wood-frame building was finished in 1895 at a cost of $17,000. There are many photographs of the handsome church exterior. Unfortunately, neither written descriptions nor photographs of the interior of the first church exist.

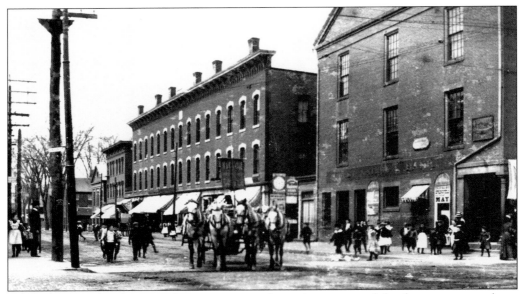

While the new church was under construction, the nation was struck by the most severe short-term depression in American history. Entire industries collapsed during the panic of 1893. There was massive unemployment in the immigrant community, resulting in near starvation conditions for Chicopee's Poles. During those hard times, the young Father Chalupka visited the homes of the community's affluent, begging for financial assistance. The monies he collected paid for food and coal. The efforts of the young priest earned him a legendary status in the immigrant community.

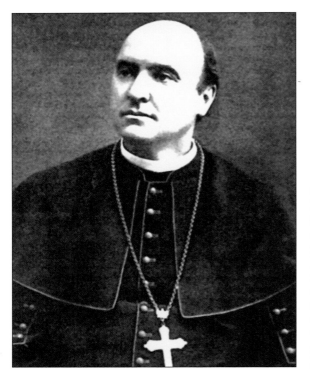

On October 11, 1895, Bishop Thomas Beaven officially dedicated the new St. Stanislaus Church. That was the same year Franciscan priests conducted missions for the parishioners. Franciscan historian Fr. Roger Haas reports that Fr. Hyacinth Fudzinski, an eloquent and forceful preacher, made a lasting impression on the young congregation. Later he would become the first minister provincial of the newly created St. Anthony of Padua Franciscan Province.

In 1895, world-famous author and social reformer Edward Bellamy lived on Church Street in Chicopee Falls. In his writings, the author saw the exploitation of immigrant labor as the beginning of a new American serfdom. In his futuristic bestseller *Looking Backward*, Bellamy envisioned the United States in the year 2000 as a classless egalitarian society.

Chicopee's 2,500 Poles were not eligible to vote in the presidential election of 1896. But a few days before the election, they each received a printed note in their pay envelope. Management's brief message indicated the mill would close if the Democrats were elected. The Republican William McKinley won the election, and the Poles kept their jobs.

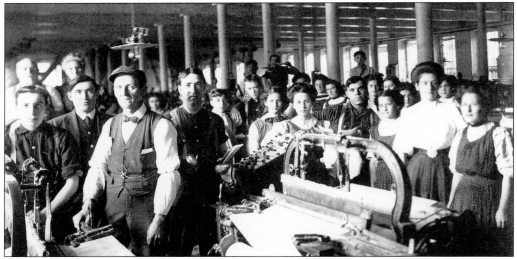

The city's Poles had joined a dissatisfied and increasingly uncooperative workforce. The low-wage immigrant workers undermined the drive for union recognition and worker's rights. American reformers were in favor of laws to limit immigration from eastern Europe.

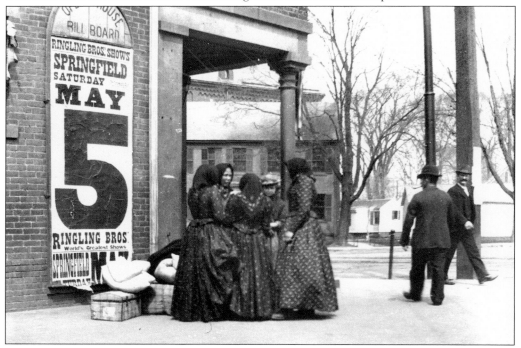

The Republican administration of William McKinley was opposed to laws restricting immigration. The flow of immigrants from eastern and southern Europe would reach flood-tide proportions in the early years of the 20th century. In eastern Poland, the combination of poverty and the Austrian government's conscription laws convinced many young men to come to the New World. In 1896, Galicia was a turbulent place. Political unrest sparked the formation of a new Polish Populist Party (Polskie Stronnictwo Ludowe), which became the first peasant political party in Europe.

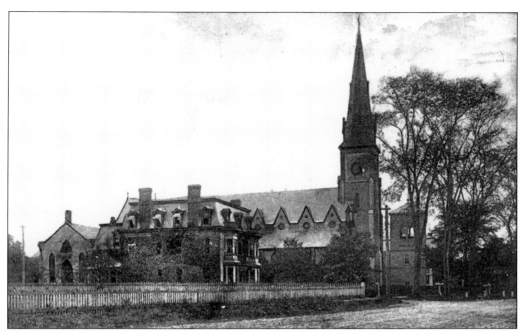

The year 1896 was an equally turbulent year for the young pastor of St. Stanislaus Church. Twelve members of the parish signed and mailed a long rambling bill of complaint to the apostolic delegate, Card. Francesco Satolli, in Washington, D.C. The charges called for a formal process, and the trial as required by canon law began in the Holy Name rectory on South Street on November 23, 1896.

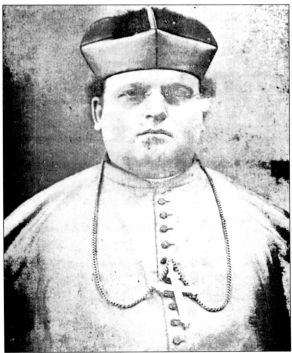

Rev. Gerard Ferrante, a canonist attached to St. Patrick's Cathedral in New York City, presided at the secret trial. Two leaders of the dissidents, Michael Frodyma and Stanislaw Boron, were notified to appear in person to hear the court's verdict. The priest was given a reprimand and returned to his parish. The dissidents sought the counsel of an independent Buffalo, New York, priest, Fr. Stephen Kaminski, and began making arrangements for an alternative parish.

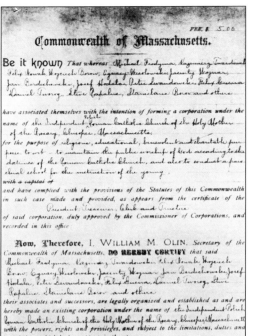

On January 5, 1897, Daniel Twarog and Wojciech Boron purchased a parcel of land at Bell and Elm Streets in Chicopee for the amount of $1,695. At a mass meeting, a temporary committee was elected to conduct the affairs of the new parish. The meeting agreed that the new parish would be called Holy Mother of the Rosary. Twenty-four parishioners signed the certificate of organization, which was approved by the Commonwealth of Massachusetts, and a charter was issued on March 10, 1897.

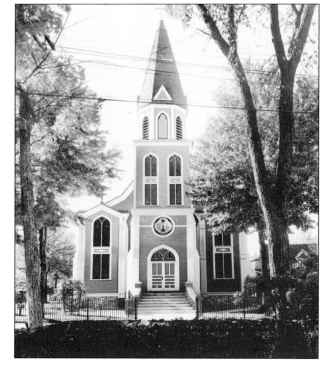

Construction of the new church began in June under contract with LaFrance and LaRiviere at a cost of $13,500. For a cemetery, the parish purchased a four-and-a-half-acre plot on Bennett Street. It was decided to build a rectory as soon as possible. Construction began and was completed in the early part of 1898. Chicopee now had two Polish churches.

Two

GROWING PAINS
1901–1915

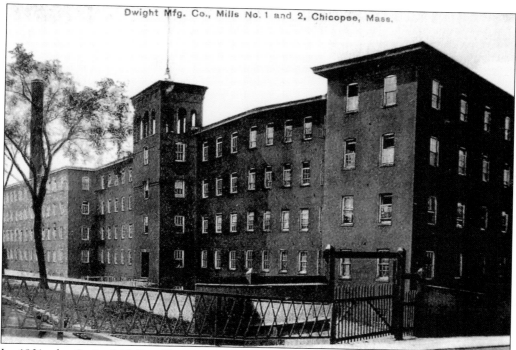

Dwight Mfg. Co., Mills No. 1 and 2, Chicopee, Mass.

In 1901, the *Springfield Republican* reported, "Chicopee Center can have no great hope of prosperity if it is simply to be a cotton mill town. The cotton mills are not to be disparaged, as they are the foundation of Chicopee and to them is due the greater part of the prosperity the city enjoyed. But if the city is to depend on this alone for the future the prospect is gloomy." The newspaper went on to describe the city as a colorful foreign enclave with over half the adult population being foreign born.

With the growth of the town, social and political life became more complex and tended to assume many of the unpleasant characteristics of a poor city community. Since the town continued to rely on the Springfield newspapers, the space devoted to Chicopee in the press was more and more given over to the recording of the police court news.

At St. Stanislaus Parish, Rev. Francis Chalupka was replaced by Fr. Stanislaus Czelusniak, OFM Conv., the first Franciscan pastor, and his associate, Fr. George Jaskolski, OFM Conv., who became the spiritual leaders of the parish in 1902.

In 1897, three Felician nuns established a school in the basement of St. Stanislaus. Sixty-five children were enrolled in four grades. They were replaced in 1902 by the Franciscan Sisters of St. Joseph. The five teaching nuns were under the direction of the school's first superior sister, M. Charles Chmielecka.

Church historian Dr. Gladys Midura wrote, "The main objectives of the Franciscan Sisters of St. Joseph, a Polish Order, were to teach children of Polish immigrants in a Polish parochial school, to instill and reinforce the religious teachings and values of the Catholic faith, and to teach children the basic skills necessary for daily living." Classes were conducted in the old church basement until 1908.

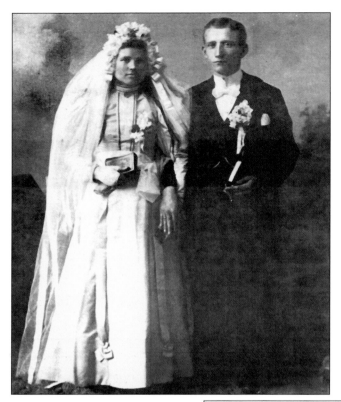

Josef Orgozalek and his brother arrived in Chicopee in the mid-1890s. They settled on Grove Street in Chicopee Falls and went to work in the cotton mills. He was still a teenager when he mastered the language of his new country. He dropped the letter r and Americanized both his names. By the time he returned to Poland to marry his childhood sweetheart, he was bilingual and a promoter of his new homeland.

Now Joseph Ogozalek, he moved his young family and opened a dry goods store at 70 Main Street in Chicopee Falls. In a short time, he would own the building. Ogozalek was a self-taught legal and real estate expert. He attended night school and even played the cornet.

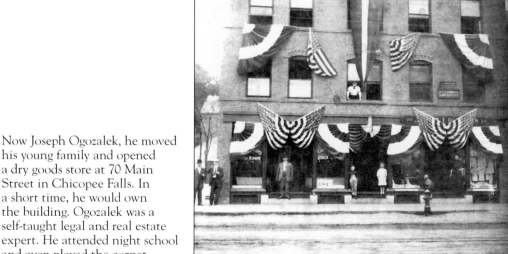

By 1905, there were multiple immigrant arrivals on a weekly basis. The Ogozalek store became a gathering place for Polish immigrants who were learning to write and speak English, getting the latest information regarding property sales, arranging to be reunited with their families who were left behind in Poland, and outfitting their children for school.

George Simonich and his wife first settled in Roxbury. But with a growing family, they relocated to Chicopee in 1903. George found employment at the Dana S. Courtney Bobbin Shop, and the family rented the old Chapin homestead on Grandview Avenue at the top of Granby Road. Simonich said it was "the most beautiful spot in Chicopee." Eventually they bought the 36-acre site and built a large new home. Mrs. Simonich admitted for the first time that they were sitting pretty.

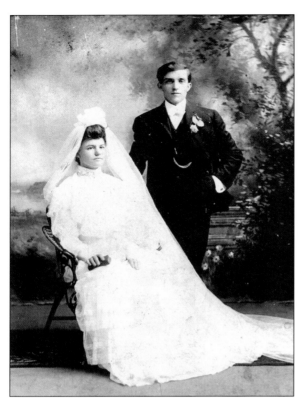

Louis Jendrysik came to Chicopee in 1901. When he arrived, there were 3,850 Polish people living in Chicopee, or about 20 percent of the city's population. He found work at the Dwight Mills. Later that same year, he married Catherine Slowik at St. Stanislaus Church. In 1904, the author's grandfather Zygmunt Jendrysik was able to come to America. He worked at the mills and lived in his brother's tiny apartment. Zygmunt's savings would unite the family when their youngest brother Felix arrived in Chicopee in 1908.

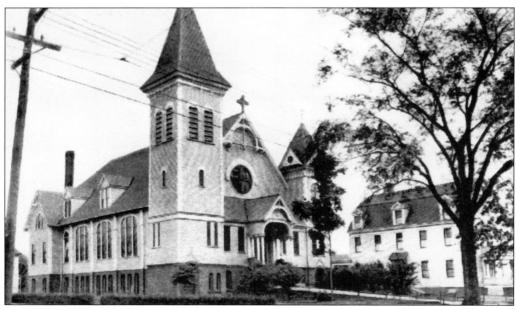

At St. Stanislaus parish, the capable new pastor in short order dissolved the parish debt and immediately set about building a new wood-frame sisters convent on Front Street, adjacent to the church. The total cost of the project was $15,000.

Dr. Gladys Midura describes Father Czelusniak as an "energetic man of strong convictions. He was a rigid disciplinarian, who demanded strict adherence to parish and church policies and regulations; deviations were not tolerated." In defense of the priest, since St. Stanislaus was the only Polish parish in the area, he was expected to minister to Poles living in Indian Orchard and Ludlow. In 1907, he authored a circular letter to Poland strongly recommending employment in the Ludlow Mills.

Ludlow, Mass.

Największe na świecie Młyny i Tkalnie Płótna

3000 ludzi zatrudnionych z czego 2000 Polaków.

Najodpowiedniejsza praca dla niewiast.

Możesz znaleść Pracę w Ludlow!

Możesz znaleść mieszkanie w Ludlow!

Dla czego nie sprowadzisz się do Ludlow?

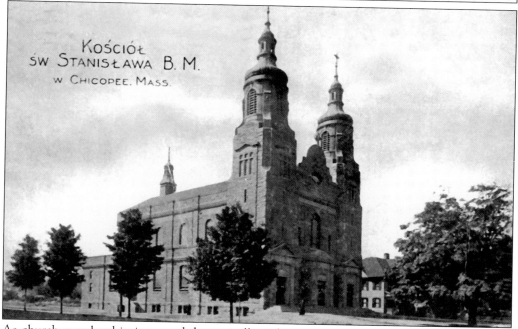

Kościół św Stanisława B. M. w Chicopee. Mass.

As church membership increased dramatically, it became apparent that the parish needed a larger building. The parishioners undertook the mammoth and costly task of building a large, magnificent house of worship. The new church was constructed 100 yards east of the first church. At the time, the new church edifice would be the largest Polish house of worship in the United States. In 1908, the author's maternal grandfather, Jan Galus, a West Springfield farmer, donated $100 for his own pew.

Rev. Thomas Daniel Beavan, bishop of the Springfield Diocese, officiated at the dedication and consecration of the new St. Stanislaus Church in 1909. The Most Reverend Paul P. Rhode, bishop in the Chicago Diocese, the first Polish bishop in the United States was the homilist. He praised the Polish people of Chicopee for their commitment to the construction of a magnificent Gothic cathedral on Front Street.

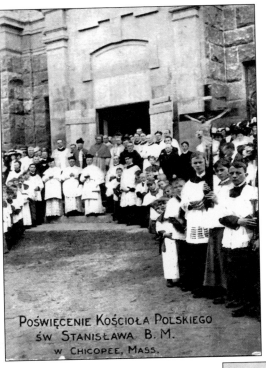

POŚWIĘCENIE KOŚCIOŁA POLSKIEGO
ŚW STANISŁAWA B. M.
W CHICOPEE, MASS.

In 1410, the Polish forces crushed the Knights of the Teutonic Order at the Battle of Grunwald (Tannenberg). With this victory over the greatest military power of the age, the Polish Kingdom ruled over a federation that stretched from the Baltic Sea in the north to the Black Sea in the south. In the east, the Polish lands extended almost to the gates of Moscow. On the 500th anniversary of this great victory, a citizens committee in Chicopee planned and financed a two-day celebration and parade.

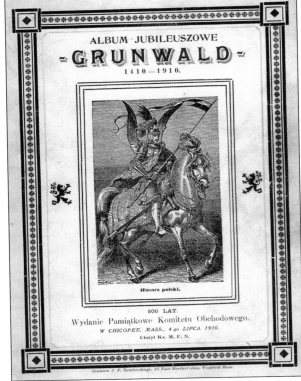

ALBUM JUBILEUSZOWE
GRUNWALD
1410—1910.

Husarz polski.

500 LAT.
Wydanie Pamiątkowe Komitetu Obchodowego.
W CHICOPEE, MASS., 4 go LIPCA 1910.
Ułożył Ks. M. F. N.

Drukiem J. F. Samborskiego, 21 East Bartlett ulica, Westfield Mass.

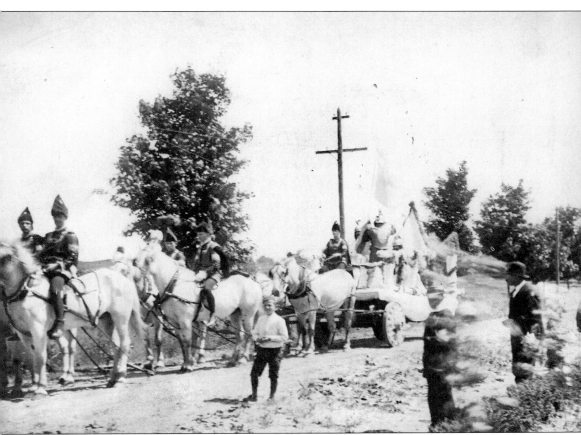

This rare picture of a horse-drawn parade float features soldiers in 15th-century armor. The audience on that Fourth of July in Chicopee was well aware of the grave situation in their homeland, but they were celebrating freedom's birthday in their new homeland. The celebration was attended by 25,000 Poles from all over the Northeast, with a large delegation coming all the way from Buffalo, New York.

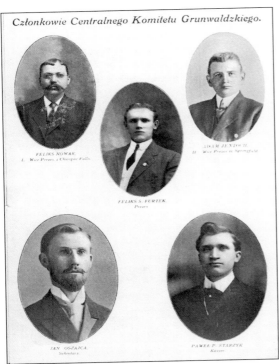

Członkowie Centralnego Komitetu Grunwaldzkiego.

FELIKS NOWAK.
I. Wice Prezes, z Chicopee Falls

ADAM JENTOCH.
II. Wice Prezes w Springfield

FELIKS S. FURTEK.
Prezes

JAN OSZAJCA.
Sekretarz

PAWEL P. STARZYK.
Kasyer

The dynamic leader of the committee, Feliks Furtek, was already a successful real estate speculator. Pawel P. Starzyk served as the treasurer. He was in real estate and operated an upscale haberdashery on Exchange Street. Jan Oszajca, the secretary, was a Springfield businessman. First vice president Feliks Nowak was from Chicopee Falls. Second vice president Adam Jentoch was the Polish agent for H. L. Handy Meatpacking Company in Springfield. Below, the entire committee is pictured with their spiritual advisor, Fr. Matthew F. Nowak, on the steps of the Chicopee City Hall. Thirty years before, marooned and penniless, the first Poles had arrived in Market Square. The message was clear. Dressed in tailored suits, cigars in hand, successful entrepreneurs were planning a civic event.

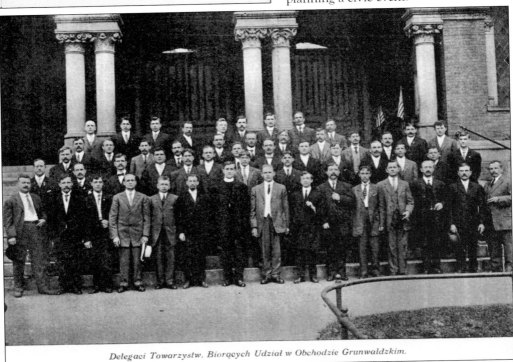

Delegaci Towarzystw, Biorących Udział w Obchodzie Grunwaldzkim.

Veterans of the Polish army organized the marching units for what the newspapers described as the largest parade in the history of Chicopee.

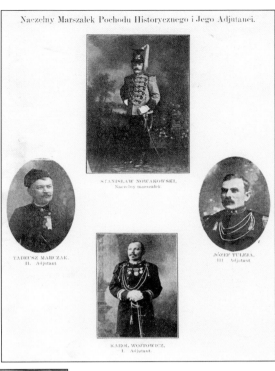

Naczelny Marszałek Pochodu Historycznego i Jego Adjutanci.

STANISŁAW NOWAKOWSKI,
Naczelny marszałek

TADEUSZ MARCZAK,
II. Adjutant

JÓZEF TULEJA,
III Adjutant

KAROL WOJTOWICZ,
I. Adjutant

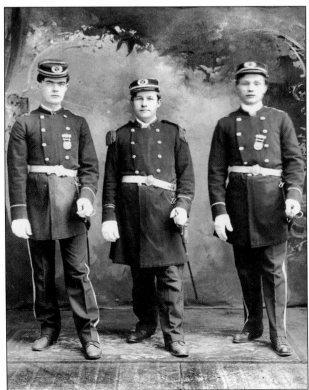

In this vintage picture, marchers pose in fraternal uniforms. From left to right, they are Paul Lubas, Walter Stec, and Walenty Konicki. The uniforms and swords purchased for the parade provided a major boost to the local economy. The swords and regalia were ordered from the Ames Manufacturing Company of Chicopee.

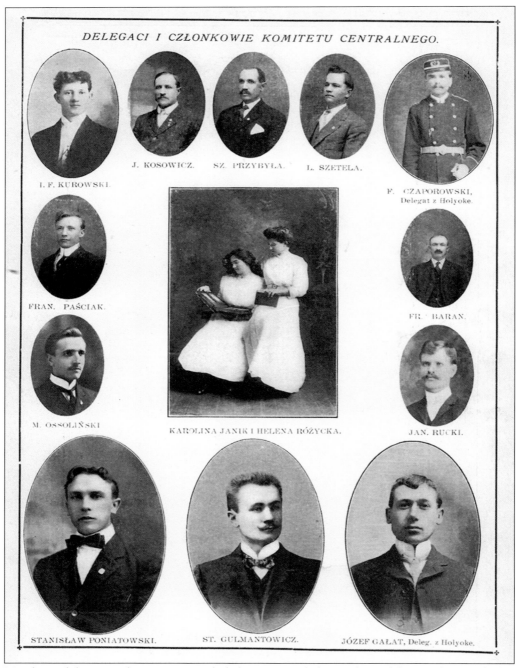

DELEGACI I CZŁONKOWIE KOMITETU CENTRALNEGO.

I. F. KUROWSKI.

J. KOSOWICZ.

SZ. PRZYBYŁA.

L. SZETELA.

F. CZAPOROWSKI,
Delegat z Holyoke.

FRAN. PAŚCIAK.

FR. BARAN.

M. OSSOLIŃSKI.

KAROLINA JANIK I HELENA RÓŻYCKA.

JAN. RUCKI.

STANISŁAW PONIATOWSKI.

ST. GULMANTOWICZ.

JÓZEF GAŁAT, Deleg. z Holyoke.

Members of the central committee included two young ladies and two delegates from Holyoke. This group handled the logistics of a three-day event and arranged transportation, food, and lodging for visitors. Even the usually critical *Springfield Republican* reported only a half-dozen arrests, admitting in print that parade security was excellent.

Before the Poles had their own church, many had worshiped in the Assumption Church on Front Street; Polish infants had been baptized there, and Polish marriages had been solemnized in that building. In 1911, the Assumption of the Blessed Mary Church was destroyed in a tragic fire. Following the fire, parishioners at St. Stanislaus shared their brand-new church with the Assumption parish for a year.

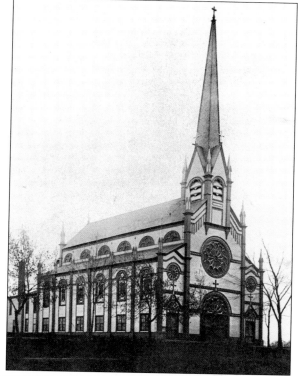

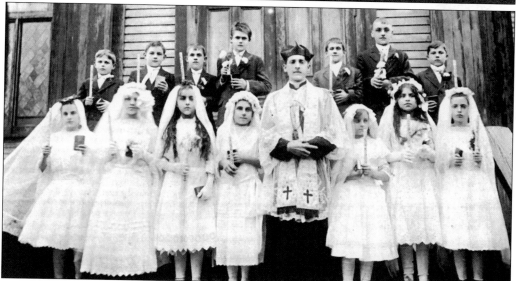

In August 1909, Holy Mother of the Rosary Parish was represented by a delegate at the Second General Synod of Polish National Catholic Church held in Scranton, Pennsylvania. The synod encouraged all independent Roman Catholic parishes to officially change the title of parish property to avoid legal problems. On January 19, 1912, a special parish meeting officially changed the name to the Polish National Catholic Church. Rev. August Krauze is pictured here with the First Holy Communion class in 1912.

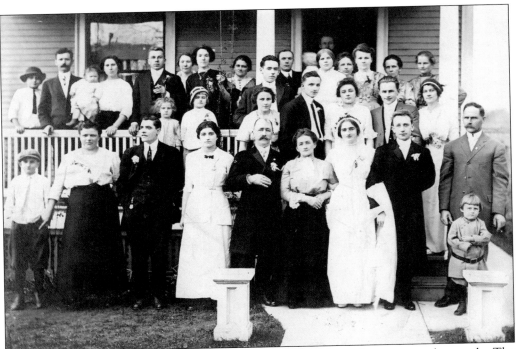

In this undated picture, the wedding party joins the bride and groom on the porch. The newlyweds are dressed in the style of the old country, while many of the well-dressed guests have adopted the styles of 20th-century America. After 1910, most large Polish wedding receptions took place in a hall. There was an orchestra and dancing. The reception was followed by a party at the bride's house, which usually lasted the entire weekend.

Zygmunt Jendrysik married Mary Chmiel in 1910. Mary died giving birth to Andrew Jendrysik. Andrew was nine months old when Zygmunt married Katarzyna Szerbik. In their wedding picture, Katarzyna has a modern dress with a hairdo to match while her husband is dressed in a three-piece business suit.

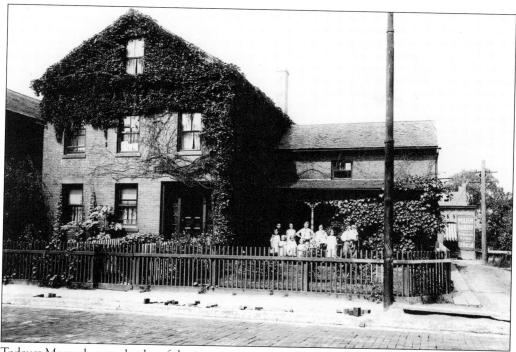

Tadeusz Marczak was a leader of the immigrant community. Here he poses with his entire family in front of their handsome home on Exchange Street. At the rear of his Exchange Street property, he operated the city's largest Polish bakery. Marczak was one of the original incorporators of the Polish National Home Association in Chicopee.

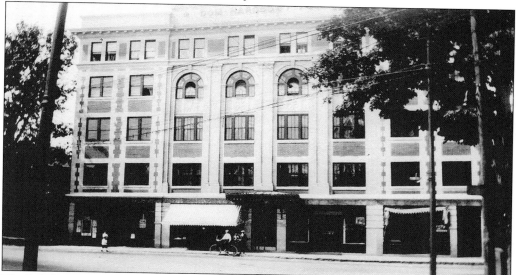

The Polish National Home Association was founded in 1911. The association purchased land on Cabot Street. The organizers raised nearly $60,000 to construct their impressive headquarters. The building was dedicated on September 20, 1914. The group's main focus was to encourage Poles in Chicopee to learn the English language and American history in preparation for citizenship in the United States.

In response to the Polish National Home Association, St. Stanislaus Church sponsored the St. Joseph's Society (Towarzystwo Sw. Jozefa). The society was established to provide an insurance plan for members and to remain steadfast in support of the faith and the church. Incorporated in 1913, the society eventually purchased an old church building on Perkins Street. The St. Joseph's Hall immediately became a popular place for wedding receptions.

Fr. Lawrence M. Cyman, who had been the co-pastor and pro-rector of Corpus Christi Church in Buffalo, New York, since 1907, was named pastor of St. Stanislaus Church. He arrived in the fall of 1914. The parish school, which was being housed in the original church building, was inadequate. A new brick addition was completed in 1915. It was the first major building project under the supervision of the new pastor.

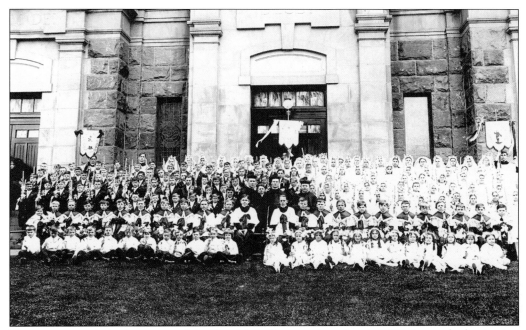

The new pastor is in the center of the First Holy Communion class in 1915. It was the beginning of the longest term of service of any pastor at St. Stanislaus Church. Father Cyman would spend a quarter-century at the Front Street church.

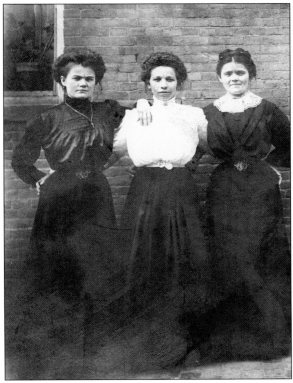

Agata Lubas (right) poses with two co-workers outside the Dwight Mills. These confident young women were a new breed of immigrant worker. Mill wages were the best in the industry. The *Springfield Republican* writes, "Every time a skinny-faced Polish family in its new clothes gets on the trolley of a Sunday afternoon for a trip to Mountain Park Chicopee industries pay their way. They make payments to 9,000-odd men and women who toil and sweat nine hours a day over the forges and the looms."

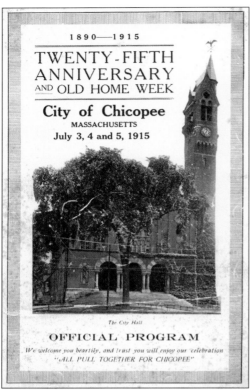

1890——1915

TWENTY-FIFTH ANNIVERSARY AND OLD HOME WEEK

City of Chicopee
MASSACHUSETTS
July 3, 4 and 5, 1915

The City Hall

OFFICIAL PROGRAM

We welcome you heartily, and trust you will enjoy our celebration
"ALL PULL TOGETHER FOR CHICOPEE"

On July 4, 1915, sixty percent of Chicopee's population was foreign born. The planners of that year's celebration were well aware of the changing nature of the community. Mayor William J. Dunn, as chairman of the celebration, selected the motto "All Pull Together for Chicopee" while dubbing the festivities Old Home Week, as it was the 25th anniversary of the establishment of the city of Chicopee.

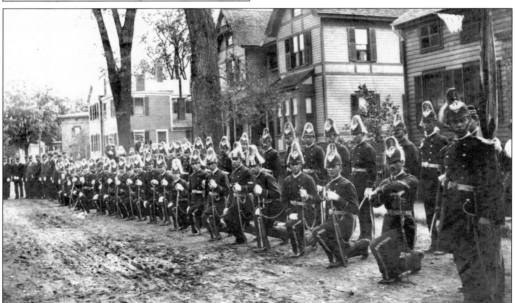

According to the 1915 city directory, there were 20 Polish associations in Chicopee. They would all march in the parade. The group pictured here at the corner of School and Dwight Street was called the Polish Lancers. The dashing young lancers in their colorful uniforms wowed the crowd with their fast-paced European marching style.

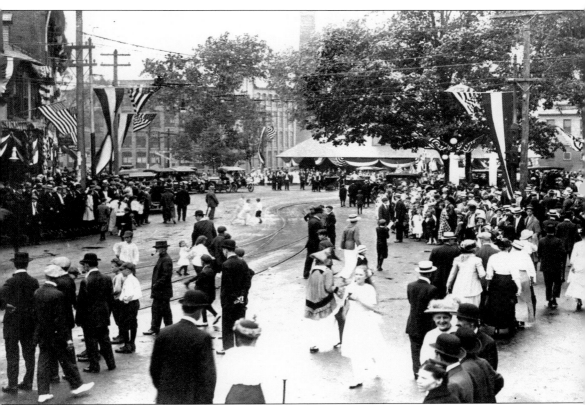

Mayor Dunn maintained a politically correct balance; two well-known speakers from divergent backgrounds would address the huge crowd. The first speaker would be a prominent Catholic clergyman, Rev. John McCoy, pastor of St. Anne's Church in Worcester. McCoy said, "The cry I am an American citizen is a louder cry today than a cry could ever have been." He closed by saying, "We will learn the great lesson that America teaches, that our country is made up of all nations and that all make up the great one people of the future."

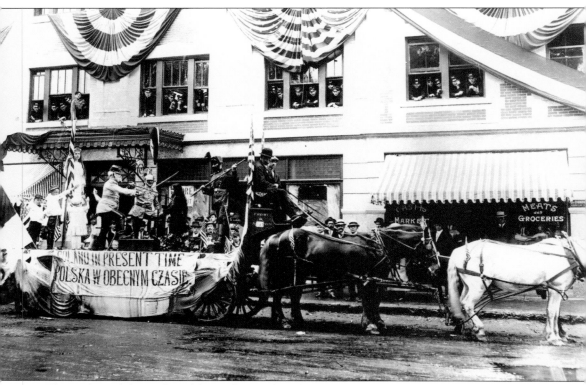

The reality of the real world was depicted in this parade float, pictured in front of the newly constructed Polish National Home on Center Street. On a serious note, the oppression of the Polish nation is vividly depicted as Austrian, German, and Russian soldiers menace a Polish peasant girl. By July 4, 1915, World War I had been raging in Europe for nearly a year.

Three

POLAND REBORN
1916–1925

In 1914, following the outbreak of hostilities in World War I, the ethnic population in Chicopee was at odds with native-born support for the Allies. The Irish were outspoken in support of American neutrality—not wanting to offer aid to the British. The French Canadians generally favored the Allied cause since both Canada and France were fighting the Germans, while the Poles saw the war as a way to establish an independent Polish state free of Austria and Germany.

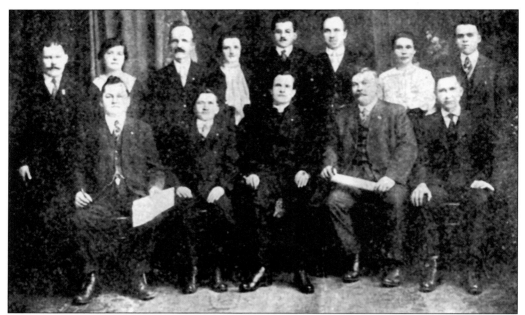

Fr. Lawrence Cyman, the energetic young pastor of the Chicopee church, became a regional leader in the Polish war-relief effort. Dr. Gladys Midura writes, "Bo'g i Ojcz'na" (God and Fatherland), words frequently repeated by Father Cyman, were representative of his dedication and devotion to God, church, and his beloved homeland. With the assistance of a citizen's committee, substantial sums of money were sent directly to the central relief committee based in Chicago.

St. Stanislaus parish celebrated its 25th anniversary as war raged across the Polish homeland. All funds raised during the week-long festivities were earmarked for war relief.

The event's blue ribbon executive committee were veteran fund-raisers in the region's Polish community. The people in Poland were undergoing unspeakable hardships. The people of Chicopee would respond with generous contributions and support.

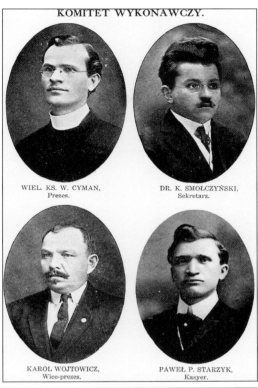

KOMITET WYKONAWCZY.

WIEL. KS. W. CYMAN,
Prezes.

DR. K. SMOŁCZYŃSKI,
Sekretarz.

KAROL WOJTOWICZ,
Wice-prezes.

PAWEŁ P. STARZYK,
Kasyer.

The 15th Jubilee Committee was composed of representatives from church societies and organizations. Church societies with national affiliations were already deeply involved in the nationwide relief effort. Concern for relatives and family in Poland led to the unprecedented involvement of the women of the parish. The appeal led by the ladies of the parish gained support from the entire community.

The Queen of the Polish Crown Society, No. 433 Polish Roman Catholic Union, was organized in Chicopee in 1909. This national organization was created to help those in need, to offer educational programs, and to provide a group insurance plan.

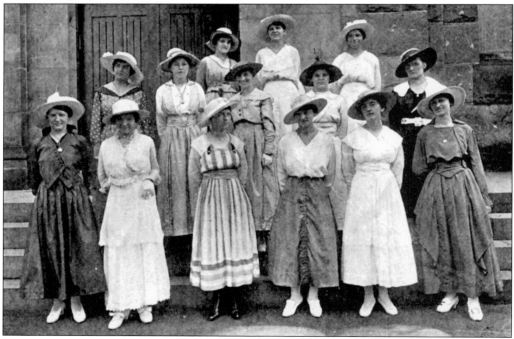

This group was composed of the wives and daughters of the leading families of the parish. The St. Hedwig Society, No. 588 Polish Roman Catholic Union, was a forerunner of the Polish Junior League.

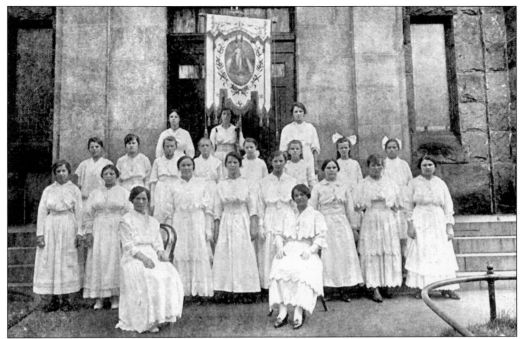

The Sodality of the Virgin Mary, beginning with its inception in 1900, was an association that dedicated itself to honoring the Virgin Mary through prayer and traditional Polish devotions; it also encouraged the development of good character.

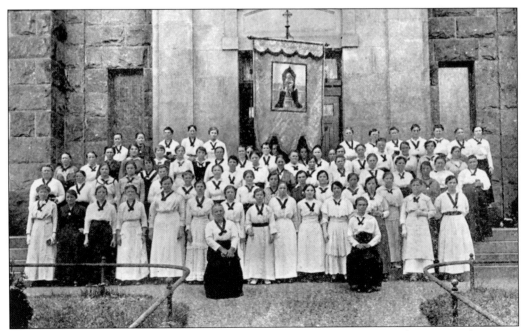

The Rosary Society, organized in 1900, honored the Blessed Virgin Mary by reciting the rosary and giving help to the needy. In 2000, the group completed 100 years of service to the parish.

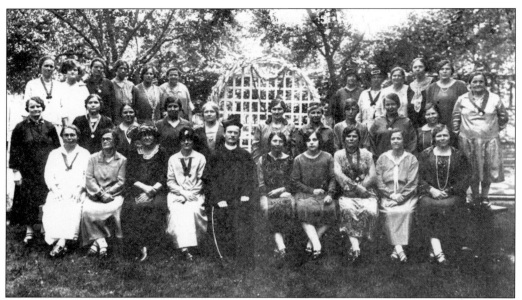

The Kolko Polek (Polish Women's Circle), formed in 1917 with the support of the Parish Citizens Committee, was formed for the expressed purpose of aiding the Polish army that was fighting in France. Following the war, the Kolko Polek concentrated its efforts toward raising funds for a new addition to the St. Stanislaus School.

At the request of German general Enrich Ludendorff, the Central Powers proclaimed a new kingdom of Poland on November 5, 1916. The Polish people, not fooled by the cosmetic granting of freedom, refused to volunteer to fight against Russia. World-renowned concert pianist, Ignacy Jan Paderewski was named head of the Polish government in exile. Paderewski visited the United States urging Poles to join the Polish army fighting in France.

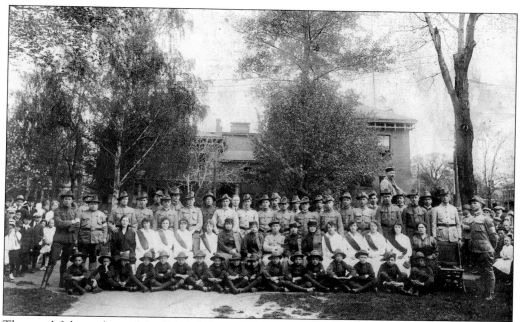

The youthful members of the Polish Falcons pose for a group picture during Polish Constitution Day festivities in 1916. The organization, dedicated to the development of a sound mind and body, was sponsored by the Polish National Home. The young people were led by Alfred Czarnota, a young Pole who arrived in Chicopee in 1910 at the age of 19. In 1916, he was the recruiting officer for the Polish Blue Army fighting in France.

Polish general Jozef Haller commanded the Polish Blue Army, which was composed of over 20,000 Polish American volunteers. Holyoke historian William Pliska reports that 500 area residents served in the Blue Army. Local records indicate 47 Chicopee men were volunteers fighting with the Polish army in France.

In Boston, Father Cyman and the Polish Citizens Committee met with Massachusetts governor Calvin Coolidge and officers of the Polish army fighting in France. On the western front, the Poles were led for the most part by French officers and saw limited combat, always fighting in conjunction with the French army. Most important, though, was the fact that the Blue Army was fighting under the ancient Polish flag.

The outbreak of war in 1914 halted all immigration from eastern Europe. For the Poles living in America, returning to the homeland was no longer a priority. In 1915, lots were available on Chicopee Street. Unfortunately, mortgage loans were difficult to obtain. Michael Skwisz, a carpenter, came to America in 1899. In less than three years, he earned enough to bring his wife, Katherine (Dudek), and his three young children, John, Stefania, and Anna, to America. The family rented at 34 Bertha Avenue. His dream was always to build a home of his own.

Michael Swisz built his dream home at 65 Chicopee Street. His family lived there until 1979, when the property was taken by eminent domain for the construction of Route 391. In 1916, land and a home of their own were still beyond the reach of most mill workers. Wages were modest; job security was nonexistent. Illness led to unemployment, and there was no workmen's compensation. Prejudice notwithstanding, bankers viewed these people as a bad risk.

Paul Peter Starzyk was born in Poland on May 11, 1876. He came to America at the age of 14 and found employment in the Dwight Mills. In 1907, he was in business for himself. For the next five years, at 258–260 Exchange Street, he was the proprietor of his own modern store selling shoes, clothing, and men's furnishings. In 1912, he sold the business so that he could pay full attention to his growing real estate holdings. Starzyk personally financed his real estate sales by lending the money to his customers. Since the local banks were not lending money to Polish immigrants, the money lenders were taking a considerable risk.

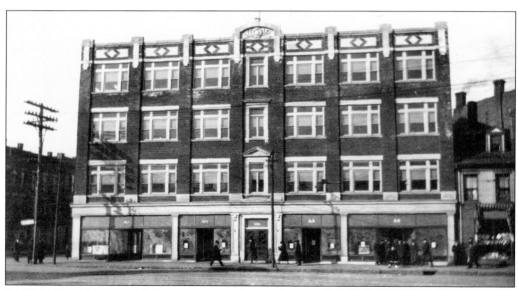

In 1916, Starzyk surprised the community by purchasing the old Doten Block facing Market Square, the municipal and trade center of the city. He acquired the adjacent Hammersley Building. He demolished both antiquated structures. In Starzyk's biography, the writer points out that "the site was within a stone's throw of the mills, where he ground out a paltry three dollars a week." The Starzyk Building is four stories high and is built of red ornamental brick, with white limestone trimmings.

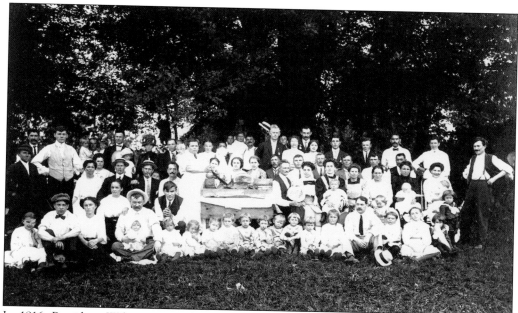

In 1916, President Wilson was seeking a second term, reminding everyone that he had kept the country out of war. This Polish picnic crowd poses for a group picture during the summer of 1916. The Poles were sharing in what the *Springfield Republican* called a wartime prosperity. Since 1914, Chicopee's largest industries, Fisk, Stevens Arms, Westinghouse, and the Page Drop Forging Company, were hiring new workers. All were engaged in war production for England, France, and Russia. Poles were moving into these skilled manufacturing jobs.

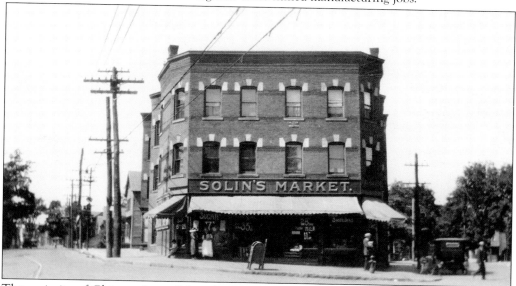

The majority of Chicopee's small Jewish community settled in the West Street section of the city. The Jewish settlers of Chicopee spoke Polish and generally found initial employment in the textile mills. By 1916, they were engaged in a wide variety of commercial business enterprises in the city. Pictured here is Michael Solin's Market, located at the corner of Center and West Streets. The store would be a city landmark for 50 years.

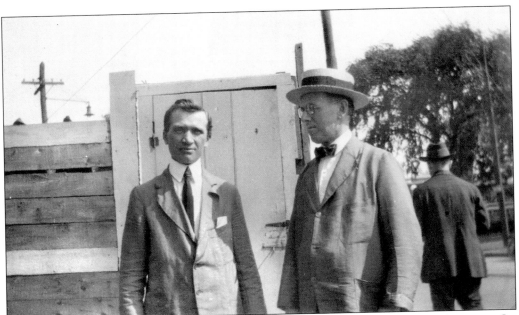

On April 6, 1917, Pres. Woodrow Wilson signed the declaration of war against Germany. On May 10, the Selective Service Act was passed, the first of its kind in the nation's history. Judge John P. Kirby (right) served as chairman of the Chicopee Draft Board and Paul Starzyk (left) served on the Exemption Board. Chicopee's first quota called 193 men. Joseph A. Lamelin was the first man drafted in Chicopee. The second was Wladyslaw Galica, and the third was Joseph Waryasz.

The U.S. Food Administration introduced wheatless, meatless, porkless days. Chicopee's backyards became victory gardens. The Poles who lived in mill tenements were allowed to establish gardens on public land. The plots produced vegetables and potatoes in record amounts. These foods were healthful and plentiful, as every backyard helped the Allies win the war.

Young Americans traveled to Europe to make the world safe for democracy in 1918. On January 8, President Wilson appeared before a joint session of Congress to announce the war aims of the United States. Wilson's Fourteen Points sent shock waves across the Polish American community. The president's 13th point called for the establishment of an independent Polish state.

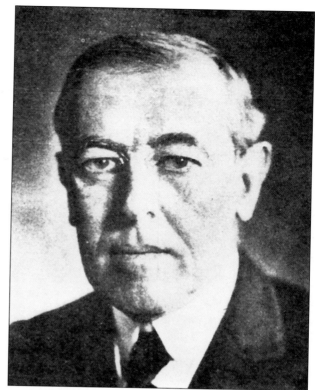

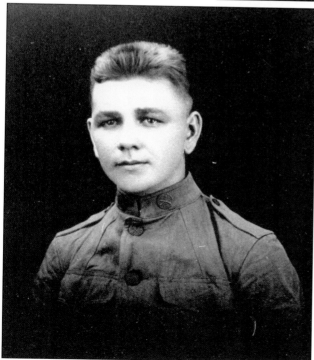

The Poles fighting in the Allied armies were now fighting for a free Poland. A member of Company G, 104th Infantry of the 26th Division of the Massachusetts National Guard was fighting in the St. Agnant Sector in France. Pvt. Frank J. Szot was killed in action on April 18, 1918, the first Chicopee soldier to die in the Great War.

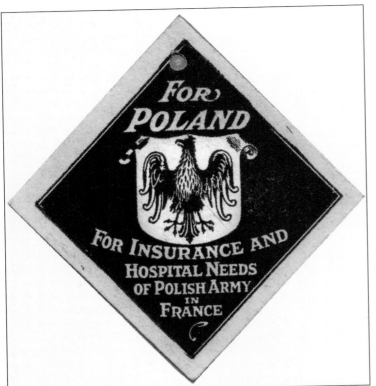

On May 18, 1918, the *Springfield Republican* reported, "Today the local Polish people are hustling to add to the hundreds of thousands of dollars their country—men the world over are trying to raise to be used for insuring the lives of the Polish Army fighting in France. Tags for Polish Relief will appear with girls to pin them—Poles hope to raise $1,000."

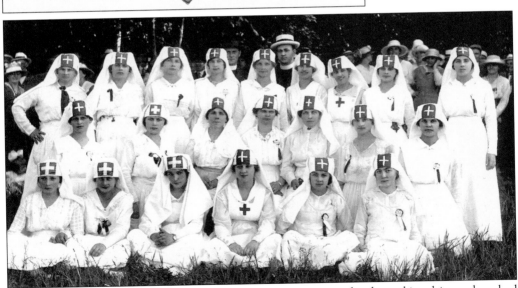

Pictured here are some of the approximately 100 young women who dressed in white and worked in pairs to cover the city in the tag day effort to secure money for the Chicopee quota. All contributors received a red tag. Those giving $2 or more had their names placed on a "golden list" and received a picture of Our Lady of Czestochowa. The newspaper reminded its readers that "Chicopee is well represented in the Polish Army in France as she has sent many of her citizens to fight under the flag."

The Germans signed the armistice on November 11. All of Chicopee participated in a huge victory parade the next day. The procession reportedly took 40 minutes to pass the city hall reviewing stand. Tragically, in November 1918, the outbreak of Spanish influenza caused 84 deaths in the city. The Polish community was hard hit, with many losing children and elderly family members. Local Poles were watching events in Paris. The Allied powers were negotiating with two competing factions, both claiming to represent the people of Poland. Roman Dmowski (right) and his National Democratic Party were at odds with Marshal Pilsudski (below) and his Polish Legion. As the Allied commissioners tried to sort things out, caught in the middle was the army of Poles from all over the world.

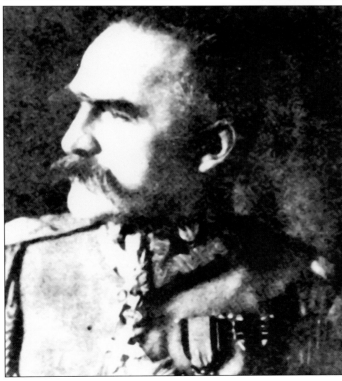

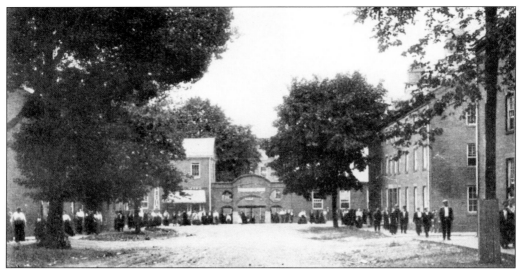

Chicopee's textile mills were the largest employers of Polish immigrants. In 1918, over 4,000 Poles worked in the industry, with nearly half that number still living in company-owned housing. The two largest employers, the Dwight Mills (Chicopee Center) and the Johnson and Johnson Company (Chicopee Manufacturing Company in Chicopee Falls), were under intense pressure to improve company-owned housing.

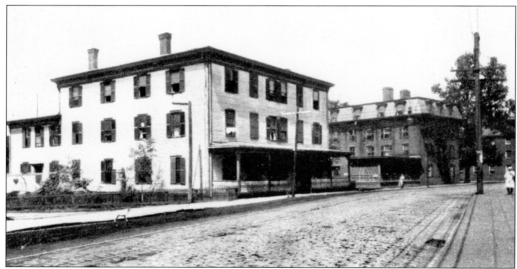

In spite of company efforts to publicize the healthy nature of mill housing, psychologists, sociologists, and educators nationwide argued for sweeping improvements in company-owned housing. In Chicopee Falls, the Johnson and Johnson Company fully renovated the tenements adjacent to the mill, referred to as China Town. The Dwight Boarding House, shown here, was part of a national advertising campaign highlighting improvements instituted by the company.

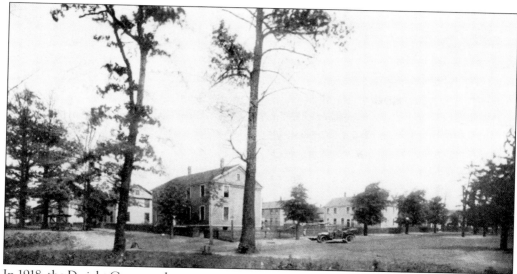

In 1918, the Dwight Company began construction of Dwight Terrace, a model community on the sandy hill across the river from the mills. In a delightful village setting, the company constructed 30 units of first-class wooden housing tenements. The majority were two-family duplex structures with all modern improvements.

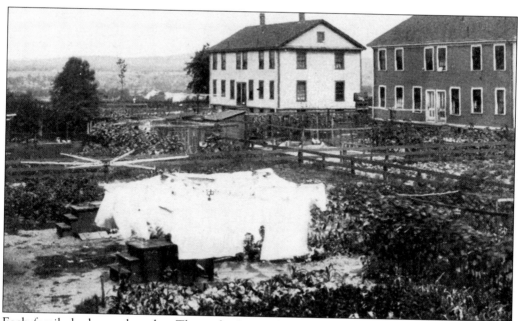

Each family had a garden plot. The author's grandfather planted several fruit trees and berry bushes. Zygmunt and Catherine Jendrysik worked at the Dwight Mills and moved into one of the brand new structures on Coolidge Road. The predominately Polish residents of the new community found the surrounding sandy hill woods ideal for picking their prized red-top mushrooms.

The Treaty of Versailles was signed on June 28, 1919, in the Hall of Mirrors in the Palace of Versailles, near Paris. Sgt. Maj. Stanislaw F. Ciosek, who later became a prominent Chicopee lawyer, was one of the few American soldiers chosen to represent the Americans at the peace conference in Paris. At that time, Pilsudski's Polish Legion was still fighting the Russian communists. The war in Poland ended on October 18, 1920, with the signing of an armistice at Riga.

Under a wartime law, no whiskey was manufactured in the United States after September 8, 1917. The states made it official when the 18th Amendment to the Constitution went into effect on January 16, 1920. Congress passed the Volstead Act, which made it a crime to make and drink alcoholic beverages. Most in the Polish immigrant community reluctantly accepted the new law.

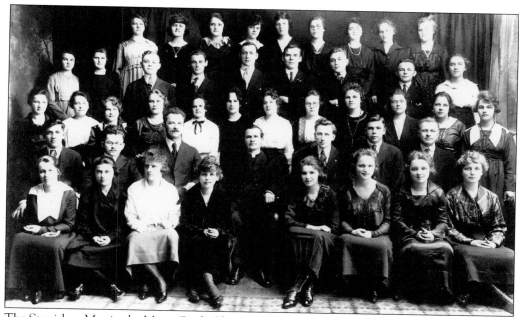

The Stanislaus Moniuszko Music Circle Choir was directed by Peter Grajewski, the parish organist. Soloists were Frances Rutka, Mary Rutka, Victoria Rutka, Aniela Szpara, and Ludwik Frankowski. The choir was the most important organization in the parish. Tryouts were highly competitive. Membership in the group was a proud achievement for the individual member and their families. In 1919, Father Cyman's St. Stanislaus Church improvement plan included a brand-new pipe organ. On May 23, 1920, the church was packed as the Moniuszko and the St. Cecelia choirs from Mater Dolorosa Church, backed by a full orchestra, presented an unforgettable concert program in Polish, Latin, and English at dedication ceremonies for the new organ.

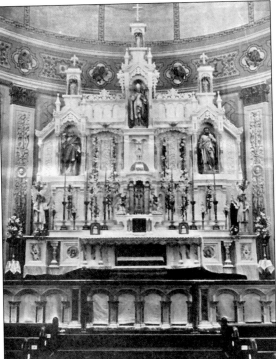

At St. Stanislaus, the church improvements included an impressive new main altar designed and built by Franciszek Szumal, an artist and sculptor from Zakopane, Poland. In the upper church, Szumal constructed a new pulpit and confessionals and redesigned the side altars.

The parish purchased land on Montgomery Street for a cemetery. The sisters convent was enlarged when an existing carriage house was attached to the rear of the original building and then converted into a chapel for the nuns.

Many Polish women still depended on a midwife. For many in 1920, doctors and hospitals were a thing of the future. Chicopee had several competent licensed Polish women who served the immigrant community. Polish children were being born at home well into the 1940s.

In Chicopee, thousands of Polish families climbed the narrow flight of stairs to the second-floor photography studio of Ignacego Fonfary. Weddings, communions, and family portraits feature the studio's familiar grey backdrop, which was used well into the 1950s.

NOWA BANKOWA INSTYTUCYA

Otwarta zostaje pod nazwą

POLISH NATIONAL CREDIT UNION

we czwartek dnia 1-go Września 1921 roku

pod numerem 222 Exchange Street, **Chicopee, Mass.**

———o———

Przyjmuje pieniądze na Oszczędność od starszych i
dzieci. Zacznij oszczędzać wybierając książeczke wkład
kową dzisiaj. Płacić będziemy procentu nie mniej jak 5
dol. od sta na rok. Procent liczony będzie od pierwszego
i pietnastego każdego miesiąca.

**Dom Bankowo-Handlowy otwarty od 9-ej rano do 9ej wiecz.
Wkładki przyjmować będziemy od 50c. w górę.**

Urzędnicy:

J. P. Kosiba,
W. Rodzeń.
I. Kowalski } DYREKTORZY
F. Kucab,
L. Garczyński. }

F. S. Furtek, Prezes.
J. A, Nowak, Vice pr.
J. J. Sitnik, Sekretarz
S. H. Grotkowski, kasyer

Komisya Pożyczek
S Swierczyński F. Modzelewski.
Komisya Rewizyjna
S. Przybyła, J. Brach.

On March 21, 1921, at 9:00 a.m., the Polish National Credit Union came into existence. Fifteen men, united by the bond of common national origin with a capital outlay of $325, were its founders. An appeal for depositors stated that money for the purpose of savings would be accepted from both adults and children. An interest of five percent would be paid on deposits and would be figured from the first and fifteenth of each month. The credit union was open for business daily from 9:00 a.m. to 9:00 p.m.

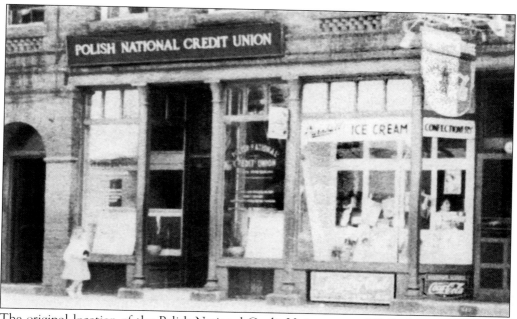

The original location of the Polish National Credit Union was at 222 Exchange Street. This bank shared quarters with a real estate and insurance firm owned by Felix Furtek. The entire space occupied by these two businesses was 15 feet wide and 25 feet deep. S. H. Grotkowski, the first treasurer, operated the institution, working side by side with Furtek, the first president. For many years, local residents would refer to the institution as Furtek's Bank.

ADW. JOSEPH A. NOWAK

JOSEPH A. NOWAK

Prokurator Sądu Dystryktowego

Adwokat i Notarjusz Publiczny

Pokoje 204-205 Starzyk Bldg.

10 Center ul. Chicopee, Mass.

Telefon 640

Pierwszy Polski Adwokat w Chicopee

The first vice president was attorney Joseph A. Nowak. He was a key player in the success of the new bank. Born in Chicopee, he graduated from Chicopee High School in 1915 and Boston University Law School in 1918. That year, he began his practice of law in Chicopee as the first lawyer of Polish ancestry. The young man, who was fluent in Polish and English, would serve as the bank's legal council for nearly 50 years.

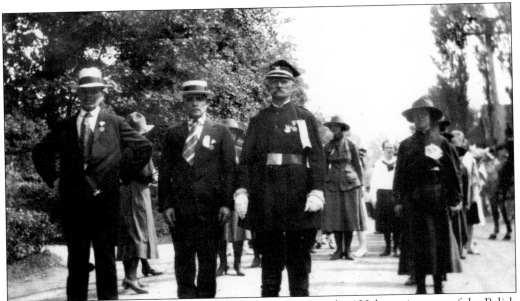

Marchers prepare to step off in May 2, 1921, commemorating the 130th anniversary of the Polish constitution. In 1791, the reform-minded members of the Sejm (Polish Parliament) drafted a new constitution. The document, known as the Constitution of May 3, was adopted that very day. Three years before in Philadelphia, the Americans had adopted a similar document. In the case of Poland, however, Russia immediately demanded that the constitution be revoked. When the demand was defied, the Russian army invaded Poland.

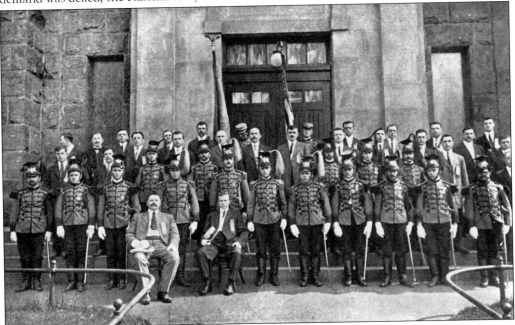

Prior to the parade the Polish Light Cavalry poses in their historic uniforms. The Polish Legion had defeated the Red Army (Russian Bolsheviks), and in March 1921, Poland had a new constitution. In the spring of 1921, for the first time in centuries, Poland was unified and free.

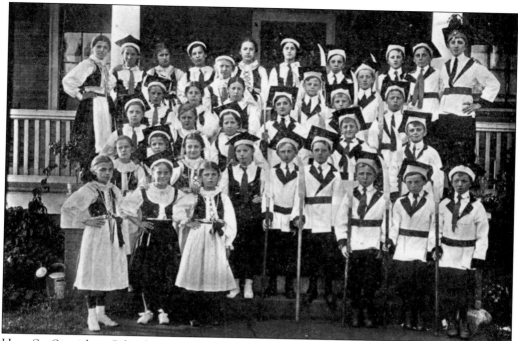

Here St. Stanislaus School ninth graders, Krakowiacy in traditional costumes, pose prior the march. In spite of the festive mood, Poles in Chicopee were sadly aware of the fact that relatives still in Poland would not be coming to America. Congress had just past a quota law, limiting the number of immigrants for the first time. The law, directed at central and eastern European countries, effectively reduced immigration from the entire region to less than 150,000 people per year.

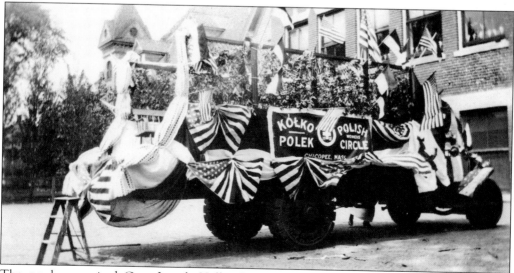

The newly organized Gen. Joseph Haller Post 168 of the Polish American War Veterans helped decorate the float. The Kolko Polek was still deeply committed to Polish relief. In 1921, the newly independent nation was struggling with unemployment, runaway inflation, and political instability.

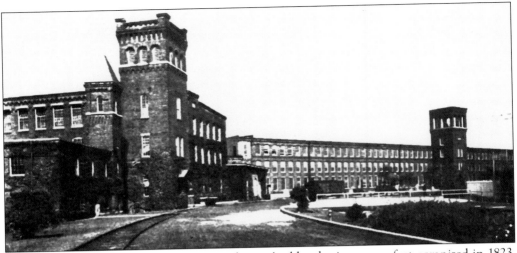

The Chicopee Manufacturing Company, the city's oldest business, was first organized in 1823. The history of the Chicopee company as an independent corporation concluded with the acquisition of the mills, in 1916, by the Johnson and Johnson Company for $1 million. By 1922, Johnson and Johnson was building a new mill in a place they called Chicopee, Georgia. New England textile mills were moving south.

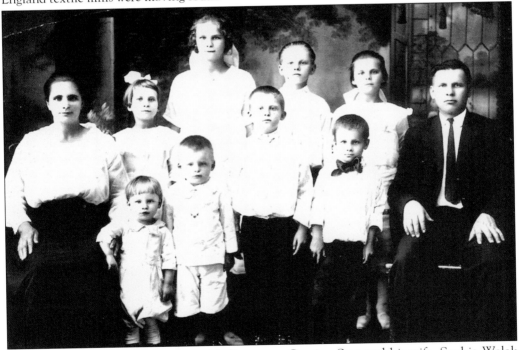

The Thorndike Mills were in financial distress, so Cyprion Stec and his wife, Sophie Wolak Stec, moved to Chicopee. The family moved into tenement housing in the Chicopee Falls Polish enclave called China Town. From left to right, they are (first row) Leo, Andy, John, and Stanley; (second row) Steffie, Rose, Walter, and Josey. A 10th child, Frank, was born in Chicopee. The Stec family was fortunate that the Johnson and Johnson Company prospered and would remain in Chicopee for 40 years.

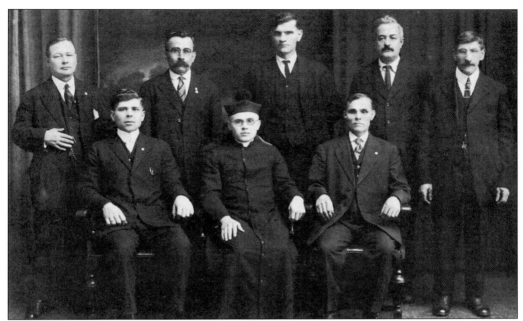

The Polish National Church of America was founded in 1897 for several reasons. The predominant one was that many Polish immigrants felt that they had little say in the operation of the Roman Catholic church, since the naming of the parishes and the ownership of the church were dominated by the American hierarchy. In 1923, Rev. Frank Wozniak was the pastor of the Holy Mother of the Rosary Church, but all the important nonspiritual decisions were made in concert with the laity.

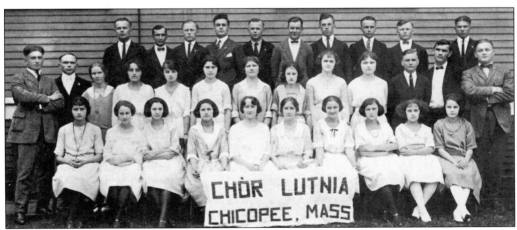

In 1924, Lutnia Choir was one of the region's best. It was the little parish's proudest organization. The parish was growing and Polish National Churches were being established in Ware, Adams, and South Deerfield. The Chicopee church established missions in Holyoke, Ludlow, and Easthampton. On August 17, 1924, the parishioners of the Holy Mother of the Rosary Church rejoiced when their first pastor, Rev. Valentine Gawrychowski, was consecrated as a bishop of the Polish National Church in Scranton, Pennsylvania.

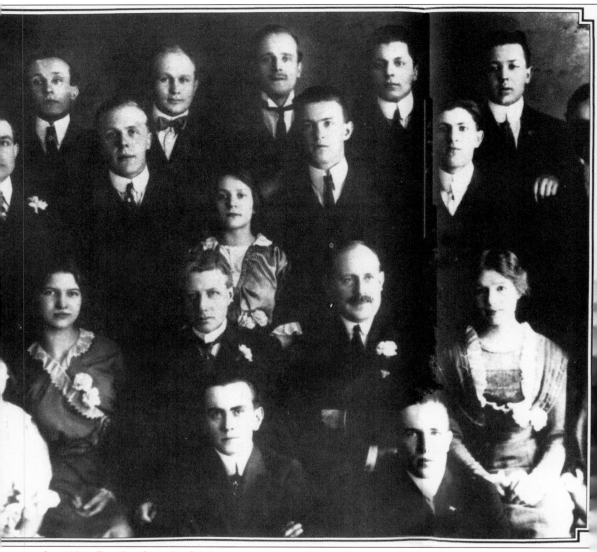

In 1924, Dr. Stephen Paul Mizwa, an economics professor at Drake University, organized the Polish American Scholarship Committee. The committee was among the first student exchange programs with the recently united Polish state. (Mizwa is in the top row, second from the left.) The scholarship committee was the beginning of the Kosciuszko Foundation. The young man who created the foundation came to America in 1909. While going to night school, he lived and worked in Chicopee and attended the Holy Mother of the Rosary Church. He graduated from Amherst College and obtained his master's degree from Harvard University. In 1955, he became the president of the foundation, serving for the next 15 years. In 2005, the 17-year-old immigrant boy's society celebrated 80 years of service to the United States and Poland. As relations between the two countries reach unparalleled levels of support and cooperation, the Kosciuszko Foundation remains in the forefront. The final resting place for this extraordinary American is a little hillock in Holy Mother of the Rosary Church Cemetery on Bennett Street in Chicopee.

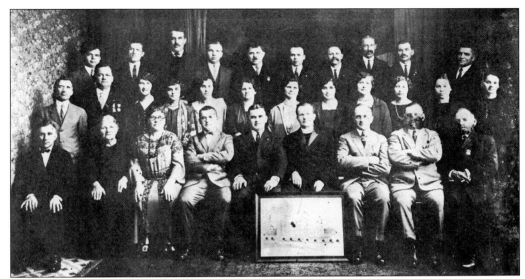

As the enrollment at the St. Stanislaus School continued to grow, plans were made to construct the proposed second section of the structure. Walter Grocki, a civic leader, served as the chairman of the fund-raising committee. The estimated cost of the school addition was $175,000. The committee, stressing ethnic pride, sent out a strong appeal to Poles in Chicopee and Chicopee Falls.

The new brick school had been designed by Bruno Wozny, the first Polish architect in the region. Wozny died in 1914. The work on the project was completed by George P. Dion, a Chicopee architect. Dion had to update the plans and specifications to comply with the state department of education requirements.

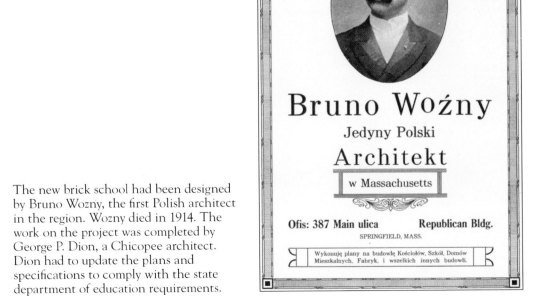

Bruno Woźny

Jedyny Polski

Architekt

w Massachusetts

Ofis: 387 Main ulica Republican Bldg.
SPRINGFIELD, MASS.

Wykonuję plany na budowlę Kościołów, Szkół, Domów Mieszkalnych, Fabryk, i wszelkich innych budowli.

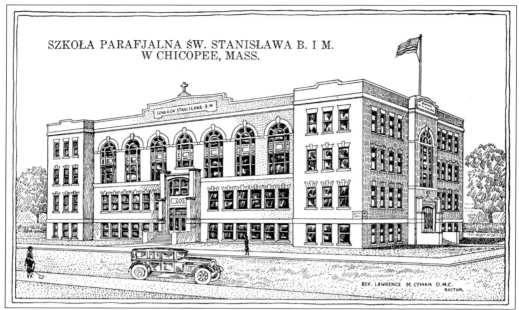

SZKOŁA PARAFJALNA ŚW. STANISŁAWA B. I M.
W CHICOPEE, MASS.

REV. LAWRENCE M. CYMAN O.M.C.
RECTOR

On September 12, 1925, a permit was issued to the St. Stanislaus Catholic Association of Front Street. The new brick school, the pride of St. Stanislaus Parish, was completed in one year and opened for students on September 9, 1926.

During construction, the old wood-frame church was destroyed and the students were transferred to the Bonneville Avenue School. The building at the corner of Bonneville Avenue and Front Street was the old Assumption Church rectory. On Bonneville Avenue in 1920, the city operated a continuation school for young people between the ages of 14 and 16 who were working part-time. The continuation school was transferred to the high school and the building was sold to St. Stanislaus Parish.

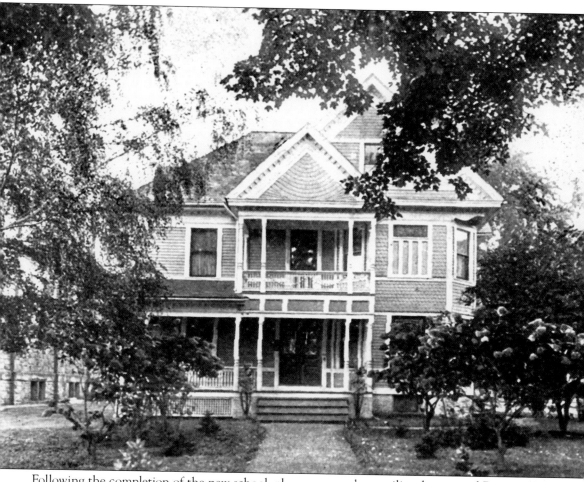

Following the completion of the new school, plans were made to utilize the vacated Bonneville Avenue School building for a needed addition to the parish rectory. For the second time, the building was placed on rollers and slowly drawn by horses to its new location at the rear of the existing parish house.

Władysław Grocki

ALDERMAN AT LARGE

KANDYDAT NA STANOWE-GO SENATORA

Wszyscy Polacy obowiązani oddać swój głos dla swego rodaka.

The first American of Polish ancestry elected to public office in Chicopee was Joseph Rutka. He was elected to the board of aldermen in 1914. In 1925, the board had two Polish American aldermen. Walter Grocki, who worked at the Fisk Tire Company, was an at-large representative. Anthony J. Stonina, a local car dealer, lived on Springfield Street and represented Ward 4. It was very clear from the outset that both men were seeking a political leadership position in the Polish community.

Felix Furtek, the first Polish American member of the Chicopee School Committee, urged immigrants to stay in school, master the English language, and become citizens. Outspoken, he favored the Americanization of immigrants and, like many French Canadians and Poles, found a political home in the state's dominant Republican party. The naturalized citizens, and the native-born first generation of Polish voters were beginning to have an impact at the ballot box.

Four

KITCHEN RACKET
1926–1933

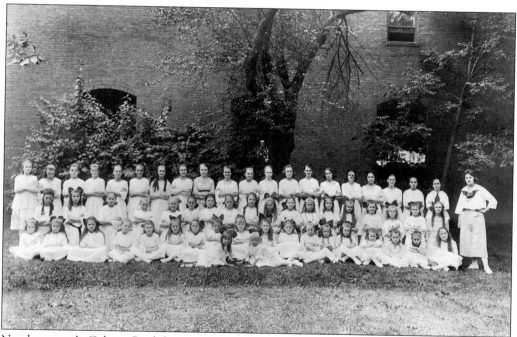

Northampton's Calvin Coolidge was the president of the United States. The United States was in the sixth year of the "noble experiment" known as Prohibition. Some local Polish entrepreneurs converted their kitchen into a mini-café, serving delicious Polish delicacies free with the purchase of the host's home brew. The Polish National Home Association reminded Poles that America was still a nation of laws. The leaders of the local Polish community urged aliens to learn the language and become citizens. Adjacent to the Center Street facility, a second building was constructed at a cost of $125,000.

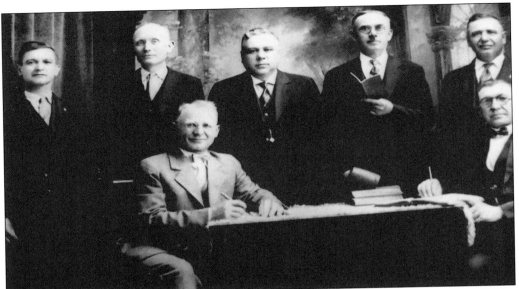

In 1926, the Chicopee Falls Polish Home was a small storefront building on Market Street. The building committee, representing a cross section of the Polish community, secured an enormous loan from the Chicopee Falls Savings Bank. The board of directors—made up of these men, Godek, Midura, Galica, Prajzner, Kulig, Stasiowski, and Rolnek—personally signed the note.

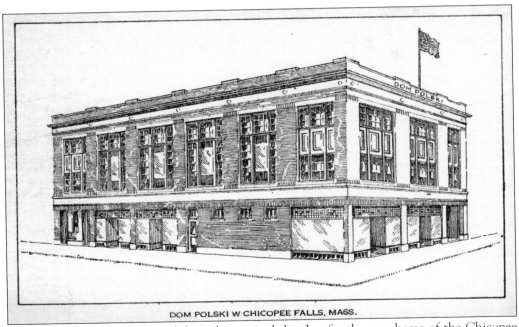

DOM POLSKI W CHICOPEE FALLS, MASS.

Stanislaw Folta formulated and drew the original sketches for the new home of the Chicopee Falls Polish Home Association. In June 1928, the dedication ceremonies featured dancing in the new Crystal Ballroom. The ballroom was the largest hall in Chicopee Falls. The building quickly became the home base for a fledgling political organization—the Polish American Citizen's Club of Chicopee.

At the beginning of the 20th century, Chicopee gained a dubious notoriety in the agricultural world by providing a name for a nearly worthless soil. Chicopee gravel covered 25 percent of the city, combined with Windsor sand and something called Hartford sandy loam. The three soils covered 80 percent of the city. During the 1920s, Polish farmers purchased land on Fuller Road and in the Ferry Lane section of Willimansett, while young Poles found work on the tobacco farms in Fairview.

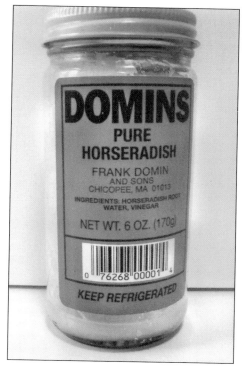

Joseph Lapa, the founder of Lapa's farm, came from Poland in 1914. He worked for a time at Moore Drop Forge before he began his farm in 1920. He purchased land on Old Field Road and leased over 100 acres of the old Chapin farmland on Chicopee Street. The horse-drawn Lapa vegetable wagon was a twice weekly visitor to Chicopee's best homes. In the 1930s, the Lapa family leased the Domin land on Mckinstry Avenue. The Domin family still markets their famous pure horseradish.

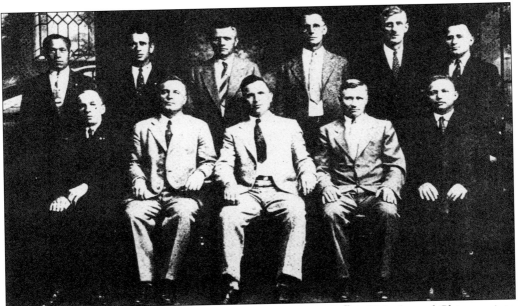

It was in 1925 that some 90 families who had relocated from South Holyoke and Chicopee into the Willimansett area met at the Pulaski Club to discuss the advisability of organizing a parish and building a church. Bishop Thomas O'Leary entrusted Rev. Stephen Musielak, then curate of Mater Dolorosa Church in Holyoke, with the task of organizing the new parish. Pictured here are the members of the Pulaski Club board of directors.

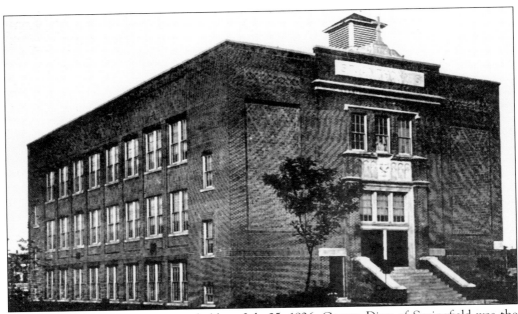

Groundbreaking ceremonies were held on July 25, 1926. George Dion of Springfield was the architect, and Boleslaus Grabowski of Holyoke was named general contractor. It had been decided that the building would house the church and school and would be constructed at a cost of $75,000.

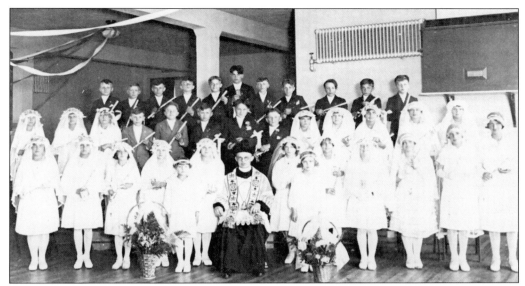

The new church was located on 14 acres of land between Senecal and Enright Streets. The land was purchased from the estate of Leo Senecal. Mater Dolorosa Church donated the sum of $9,500 for the purchase of the land. St. Stanislaus Church of Chicopee donated a church organ and a new boiler. Rev. Celestine Rozewicz is shown here with the church's first Holy Communion class.

The first pastor of the new St. Anthony of Padua Parish converted a room over the sacristy to serve as living quarters. Father Rozewicz, pictured here with the St. Anthony's first choir, received permission to construct a rectory adjacent to the church. The rectory was completed and occupied in time for Christmas 1927.

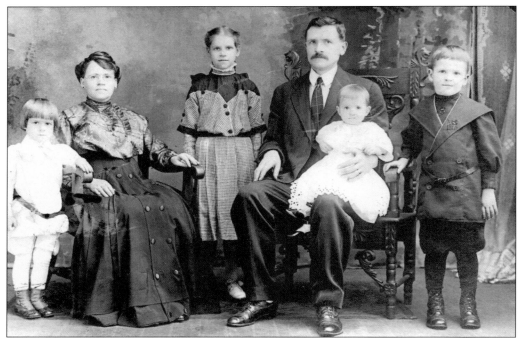

When Bertha Ossolinski arrived in the United States, her first stop was Salem. She migrated west to Chicopee, where she met Jozef Czelusniak. When they married, she worked in the Dwight Mills, and he was a meat cutter at the Springfield Provision Company. In June 1900, they moved into their first home, at the corner of Nonotuck and South Street. The Czelusniaks had four children—Emilia (1901), Matthew (1905), Henry (1908), and Matilda (1910).

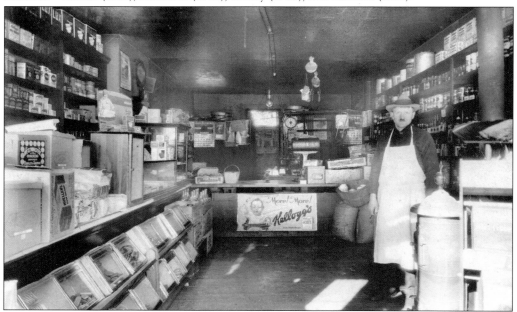

Jozef Czelusniak operated two stores (meat and furniture) at 90 and 92 Exchange Street. He was busy in his stores from sunup to sundown.

The family prospered in their new home on Center Street. With Jozef busy at work, Bertha was the first woman in Chicopee to have her driver's license. She bought a brand-new car, an Oakland, from A. J. Stonina at the Dunbar Auto Sales in Holyoke. On summer mornings, the young mother of four would hustle the kids into the car. They would pack two picnic baskets and head off for Nantasket Beach in Boston.

They were living in a fine Victorian home on Springfield Street when the family posed for a 25th wedding anniversary photograph. All four of the Czelusniak siblings were college graduates. They are, from left to right, Matt (Northeastern University), Matilda (Massachusetts School of Art), Emilia (Westfield State College), and Henry (New York University).

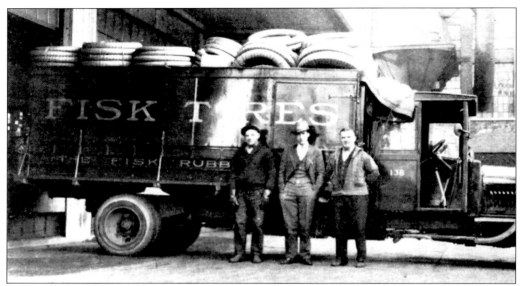

In the 1920s, the best place to work was the Fisk Tire Company, on Grove Street in Chicopee Falls. The company, the region's largest employer, published a monthly magazine called the *Fisk Candle*. In this picture, road transportation department foreman James Harrington and drivers Ernest Benoit and Walter Grocki pose with truck No. 138. The magazine described Grocki as one of Chicopee's best-known and popular political luminaries.

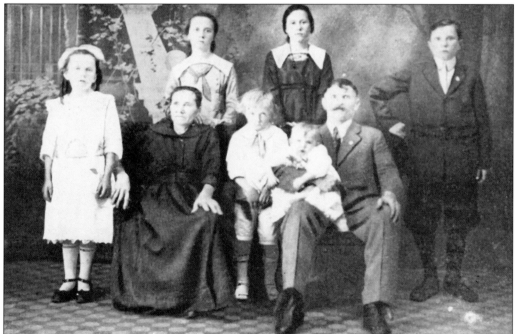

When this picture was taken, Martin Biernacki had been employed at Fisk for 10 years. The magazine indicated that he had been a faithful employee of the yard department, adding that "he is a strong supporter of the company's Americanization classes where he attends regularly even tho he has been naturalized."

The *Fisk Candle* commented that Stella Brodacki of the tube room (right) was in a serious mood when she had this picture taken. At the left is her sister Mary, who worked in Department 5A of the administration building. The writer pointed out that "both sisters have 'oodles' of friends because of their wonderful dispositions."

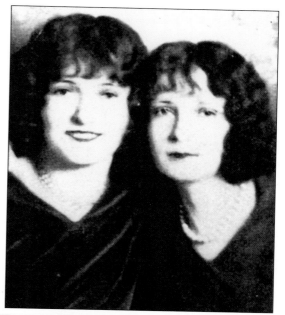

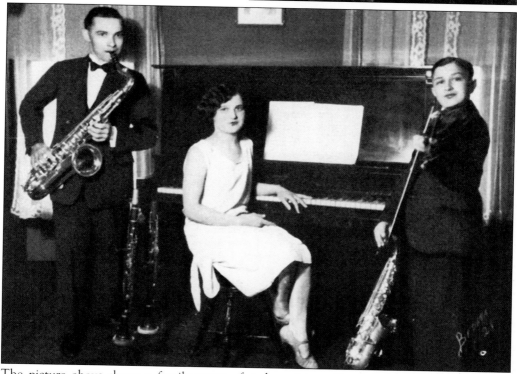

The picture above shows a family group of real musicians. Frank Pelczarski, a 20-year Fisk tire maker, plays the saxophone. His daughter Frances sings and son Stanley plays the violin. These three, grouped with several other Chicopee musicians, are known as Pelczarski's Melody Boys. Under the leadership of Frances, the orchestra played at parties, dances, and weddings. Occasionally it was heard on WBZ Radio in Springfield.

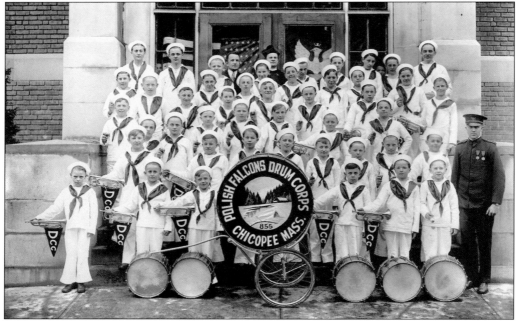

The newly organized Polish Falcons Flute, Trumpet, and Drum Corps was featured in the *Fisk Candle*. The magazine noted that the bright-looking boys in the picture make up one of Chicopee's finest drilled musical organizations. The writer pointed out that numbered among them are the sons of several well-known Fiskers. He added that the organization, while young in years, always makes a good account of itself. He finished by reminding his readers that the bass drum rolls on Fisk tires.

In 1919, A. J. Stonina and his brother operated the Chicopee Tire and Accessory Store. The company sold Oakland Pontiac Sensible Sixes and sponsored the Oakland Athletic Club. Pictured here with the club's returning veterans, the young man was poised to launch his political career.

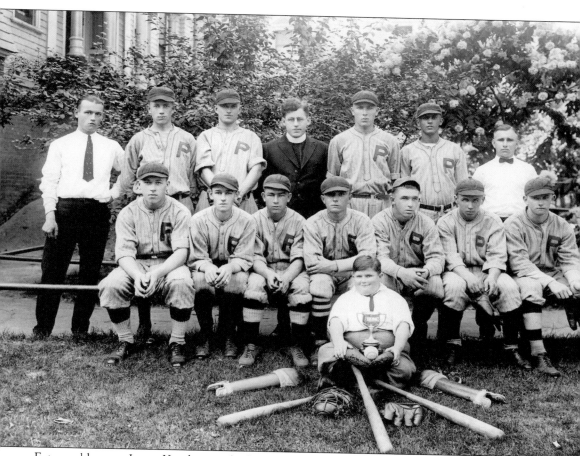

Future alderman Larry Kendra coached the Polish American Young Men's Association team, which won the 1924 Chicopee City League. From left to right are (seated) Frank Rickus, Tony Bielizna, Joe Kumor, Frank Wojtowicz, Mike Bogdan, Charlie Cyran, and Peter Bardon; (standing) manager Tom Blazejowski, Joe Strzepek, John Marek, Rev. Raphael Marcinik, Steve Ptaszek, Tony Koziol, and coach Larry Kendra. The batboy is Walter Wozniak.

Anthony Cyran was born in Poland on February 25, 1883, and came to Chicopee with his parents when he was three years old. He attended St. Stanislaus School and the school of the Resurrectionist Fathers in Buffalo, New York. He was ordained in the Montreal Cathedral on January 1, 1908. A few days later, he celebrated his first mass in the brand-new St. Stanislaus Church. Reverend Cyran was the first son of the parish to celebrate mass in the Chicopee church.

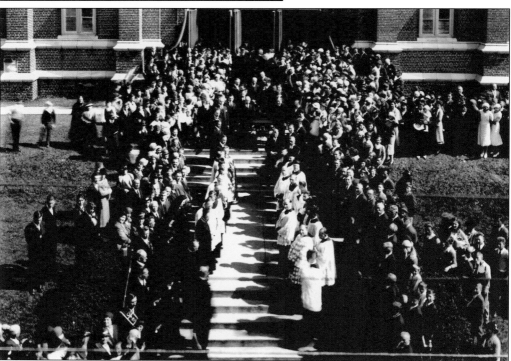

Father Cyran's first assignment was in Clinton. Later he was transferred to Webster, where he had a long career as curate and then as a pastor of St. Joseph Church for 23 years. When he died on September 14, 1933, the *Worcester Telegram* wrote, "The Webster pastor, the only Polish monsignor in New England, was one of the most widely known prelates in New England." The paper said of the funeral, "Never before, in the history of Webster, has such a body of churchmen been gathered in a local edifice."

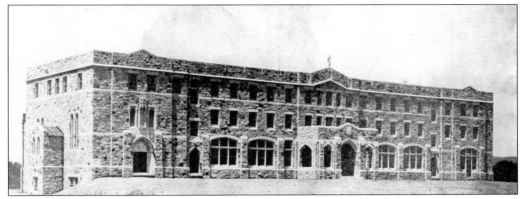

In 1927, Rev. Thomas M. O'Leary, bishop of Springfield, consecrated the new St. Hyacinth's Seminary in Granby. It was the beginning of an extraordinary relationship between the young friars and the Front Street church. The relationship took on a very special meaning during the Easter and Christmas seasons. The blessing of homes at Christmas and the blessing of food—Swieconka—at Easter made the holiday visits truly memorable for the young priests.

A number of parishioners became Franciscan friars. John and Stanislawa (Sulewski) Kozikowski head the list of parishioners with sons in religious careers. Four of their sons became Franciscans. From left to right, Fathers Henry, Julius, Stanislaus, and Paul devoted 151 years to the service of God and his people.

The club was created in 1921 as a new parish society to meet the changing educational, recreational, and social needs of young women. By the end of the decade, the politically active organization was the most popular church society. Lucja Wisinowska was the president, while Aniela Pieciak, Karolina Wozniak, and Stefanja Tupaj were members of the executive committee.

ALBUM

I

PROGRAM

Instalacji

Gniazda 855 Związku Sokołów Polskich

W CHICOPEE, MASS.

Dnia 28-go Października, 1928 roku.

At the Polish National Home, during World War I, the Polish Falcons recruited soldiers for the Blue Army fighting in France. The Falcons were based on an organization founded in Poland in 1867. The first "nest" or lodge organized in this country was by Felix L. Pietrowicz on June 12, 1887, in Chicago, Illinois. In 1928, Father Cyman initiated the establishment of a new Nest (No. 855) at the St. Stanislaus Club.

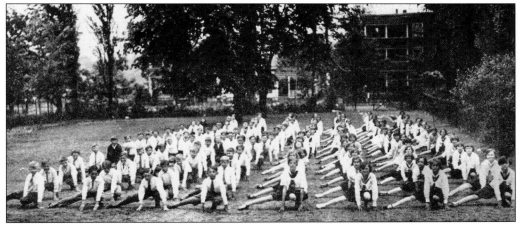

The new group would downplay the organization's military past. Parochial school youngsters were urged to join the Falcons. From its early beginnings, the Polish Falcons have had the motto "A Healthy Spirit in a Healthy Body." Nest No. 855 conducted gymnastics exercises, group drills, and mass calisthenics. The lodge organized a drum corps for parochial school students.

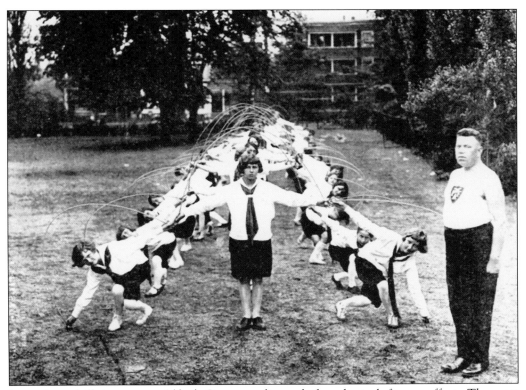

Legendary drill instructor Alfred Czarnoty directed the physical fitness effort. The nest sponsored teams in volleyball, basketball, baseball, softball, and table tennis. Nest No. 855 catered to young first-generation Americans, introducing them to recreational sports like tennis, golf, and bowling. Hundreds of youngsters attended Falcon Youth camps, where cultural and social activities included folk singing, dancing, choir, and drama.

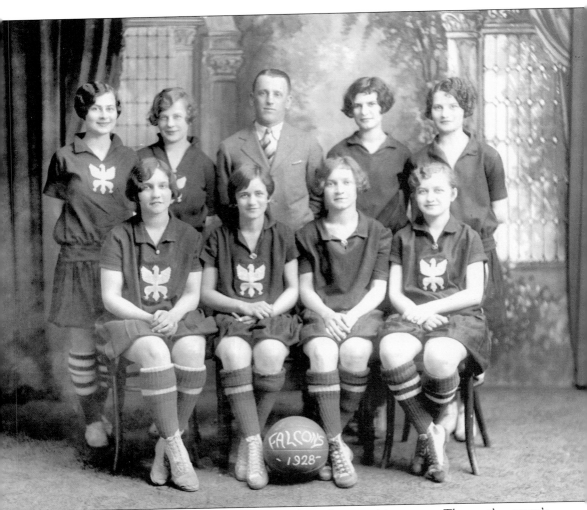

In the 1920s, Chicopee's ethnic community embraced competitive sports. The nest's women's teams excelled, playing in the city league and competing against Falcon units from all over New England. From left to right are (first row) Zofja Wojtasiewicz, Stanislawa Bigda, Anna Wojasiewicz, and Stefanja Przybyla; (second row) Stanislawa Piekos, Katarzyna Klaus, Anthony Cyran (manager), Jozefa Jamroz, and Stanislawa Jamroz.

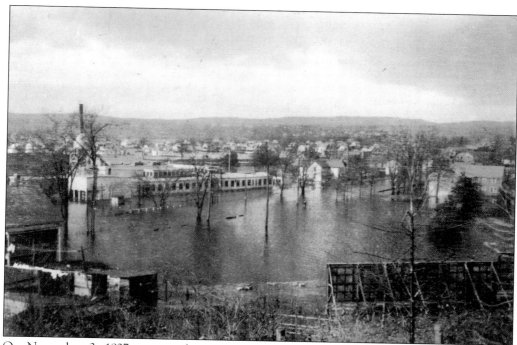

On November 3, 1927, torrential rains struck the Pioneer Valley. The following morning, oversized newspaper headlines declared "Worst Floods in Quarter Century Sweeping Western Massachusetts." Pictured here, the predominately Polish Ferry Lane section of Chicopee was one of the area's hardest hit.

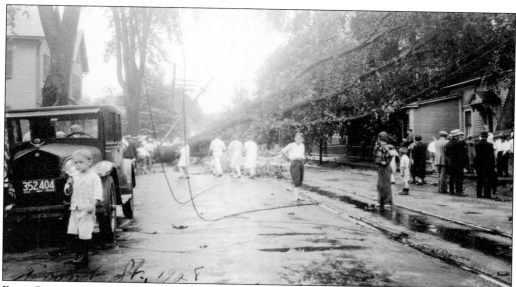

Front Street is pictured here as residents survey the damage of a summer thunderstorm in 1928. For the next decade, Mother Nature would wreak havoc on the Pioneer Valley. Bad weather, combined with the loss of Chicopee's largest employer, made 1928 a very bad year for Chicopee Poles.

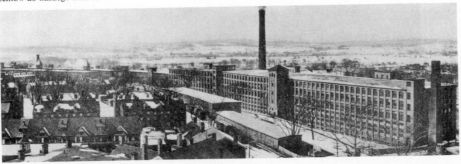

Cradle of Poles
Dwight Manufacturing Co., Chicopee, Mass.

Jeden z Najwiękoszych, Najlepiej Urządzonych Odpowiednich Młynów w Kraju.
Świeże Powietrze, Dobre Światło, Dobra Praca.

Opłaca się pracować w Młynie, gdzie praca jest stała przez cały rok. Zapłata taka na jaką tylko którykolwiek Młyn zdobyć się może. Praca dla wszystkich mężczyzn — kobiet i dzieci od 16 roku życia. Chicopee jest pomiędzy Springfield i Holyoke — 5 centów do każdego miasta.

Staramy się aby mieć jak najwięcej Polskich robotników i aby otrzymali jak najwyższy zarobek. Niektóre familie mają znaczną sumę pieniędzy jeżeli cała familia pracuje.

Nasze mieszkania są czyste i dobrze trzymane. Dużo z naszych robotników posiada własne domy, co udowadnia że Chicopee jest odpowiednie miejsce do pracy i zamieszkania. Śliczny Polski Kościół. Piękną Polska Szkoła. Bezpłatna szkoła wieczorna dla nauki języka Angielskiego.

The above 1890's advertisement to Polish immigrants to come, work and live at the Dwight Cotton Mills in Chicopee.

This 1890s advertisement urged Polish immigrants to come, work, and live at the Dwight Cotton Mills in Chicopee. By the 1920s, the New England textile industry was mired in financial difficulties. Chicopee's factory wages were the best in the industry, but plants were outdated and were located a considerable distance from the raw materials.

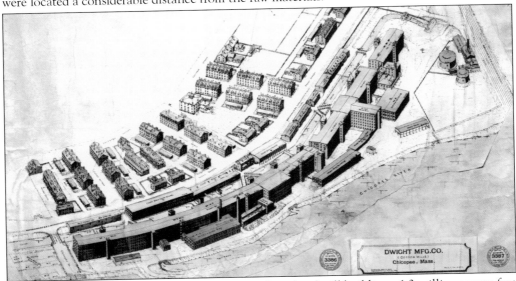

The Dwight complex contained over a quarter of a mile of mill buildings, 1.3 million square feet of space spread over 14 acres on the edge of the Chicopee River. Mill owners in Massachusetts objected to the stringency of the state's safety laws, the increasing taxes, the limits on working hours for women, compulsory insurance and unemployment compensation taxes, and child labor laws. Following World War I, J. Pierpont Morgan's holding company had purchased a large block of Dwight stock.

In the 1920s, the company was annually using 15 million pounds of cotton to manufacture the famous Anchor brand of cotton cloth, which was shipped all over the world. The Dwight Anchor brand of sheeting was the Cadillac of cotton sheets, while the company's affordable Star brand was the nation's largest selling bed sheet. As the economy boomed in the 1920s, profit margins in the textile industry were shrinking along with shareholder dividends.

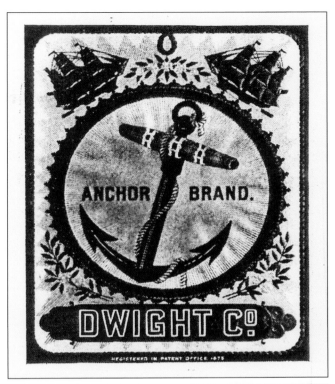

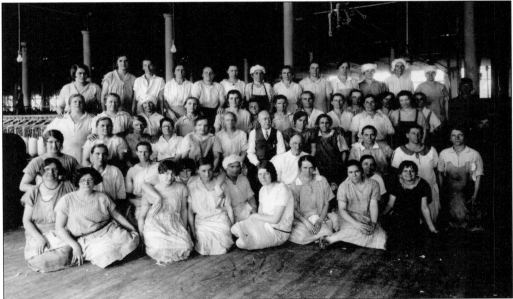

During the five years before the final shutdown, the Chicopee plant was closed by several strikes. In 1925, the *Wall Street Journal* began predicting widespread plant relocations to the South as the only way to improve earnings in the declining textile sector. In 1928, the Morgan interests moved the company to Alabama, leaving most of the machinery still in the mill. The city lost its largest taxpayer. Some 2,000 workers—most of them Poles—were now unemployed.

In 1921, successful Chicopee businessman Leon W. Szetela purchased *Nowa Anglia*, the city's only foreign-language newspaper. Printed in the Polish language, the paper had concentrated on news from the homeland. The new ownership changed the paper's focus almost exclusively to the United States with a clear emphasis on local affairs.

On the paper's masthead, a new mission statement declared, "A weekly journal printed in the Polish language, whose purpose is to tell the story of America. Its history, its government, its life. So that the reader appreciating obligation and privileges of American citizenship, will meet everyday problems of existence with fairness, intelligence and strength."

In 1927, Leon Szetela launched a weekly paper. The *Chicopee Herald*'s first editorial decried unfair tax assessments that "soak the Polish." His publishing company, the New England Press, would support Polish Citizens Clubs and a full slate of Polish American candidates for local office. When Chicopee auto dealer A. J. Stonina made his first run for mayor in 1929, he had the full support of both of the city's newspapers.

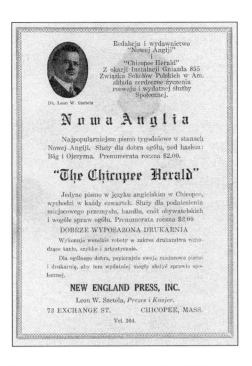

In the 1920s, Franco-Americans in Chicopee were the first to openly call for a block vote in the mayoral contests. A few weeks after the stock market crashed, Mayor Henry Cloutier won a close victory over a Polish American challenger. The Springfield newspapers referred to the situation as racial politics. The terminology was incorrect, but the story was right on target. The newspaper wrote that the Polish American political combination was now a force to be reckoned with.

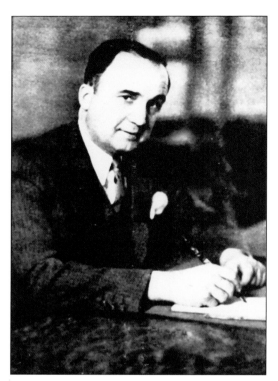

Tony Stonina and his new coalition swept into office in 1931. At 33 years of age, he was the youngest mayor in the city's history. He was New England's first Polish American mayor. His supporters controlled the city's board of aldermen. He would dominate local politics for the next eight years. Self-assured, flamboyant, and confrontational with the arrogance of a revolutionary, A. J. Stonina would engender passionate support and fierce opposition.

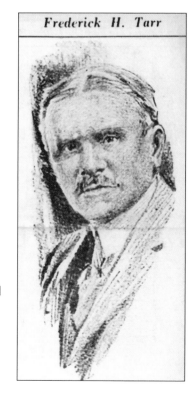

Frederick H. Tarr

Stonina had become the chief executive of a nearly bankrupt city. In 1932, one-third of the city's workforce was unemployed. During his election campaign, he had promised more city jobs. Instead, the mayor was cutting wages and laying off city workers. The Stonina administration suffered when some of the mayor's prominent supporters were indicted for violations of the Volstead Act and federal gambling laws. U.S. attorney Frederick H. Tarr's investigations had been going on for two years.

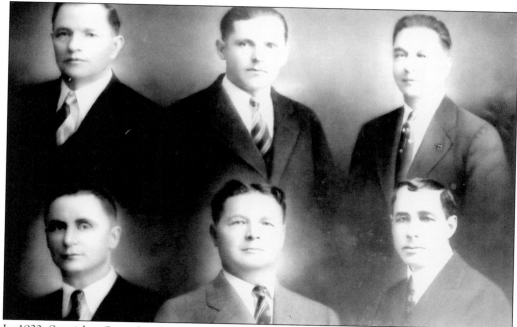

In 1932, Stanislaw Sitarz lived at 76 Orchard Street. He was a member of the board of aldermen and a leader of the Polish community. He was also the man who created the first Blue Seal kielbasa. The company had a new kind of sausage (lean, not greasy), catering to an American taste. The founders of the company are, from left to right, as follows: (top row) Stanislaw Sitarz, Bartlomiej Partyka, and Jacob Sitarz; (bottom row) John Szczepanski, Walter Kaminski, and Antoni Budnarz.

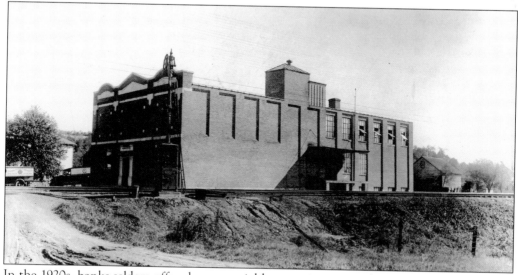

In the 1920s, banks seldom offered commercial loans to immigrant businessmen. The decision to expand was a bold gamble. In 1926, the partners purchased land off Chicopee Street. A rail spur, slaughterhouse, and a modern smokehouse were constructed at considerable cost. The company became incorporated on December 31, 1931, as the Chicopee Provision Company, the manufacturers of Blue Seal table-ready meats and specialties.

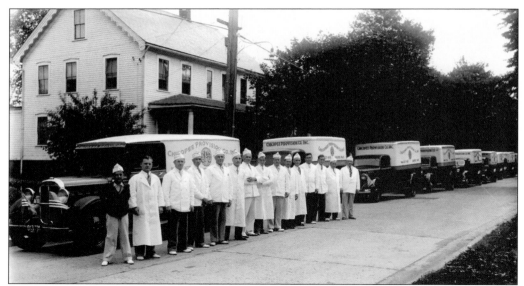

In the 1930s, before the advent of the supermarket, the company delivered to hundreds of small markets. The Blue Seal brand was unsurpassed for freshness and quality. With the new quarters and a fleet of delivery trucks, the company would sell their products wholesale up and down the Pioneer Valley and south into northern Connecticut. Today, customers can order Stanislaw Sitarz's kielbasa on-line.

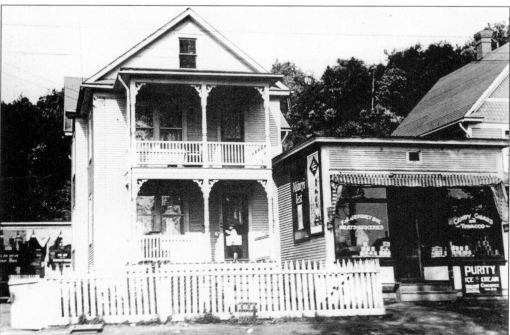

Chicopee Provision's best customers were the small, family-operated stores located in the valley's ethnic Polish neighborhoods. In 1919, the author's great-uncle Felix Jendrysik quit his job at the Dwight Mills Machine Shops and opened a small grocery store next to his home at 69 Chicopee Street. On July 1, 1924, Felix Jendrysik became a citizen of the United States.

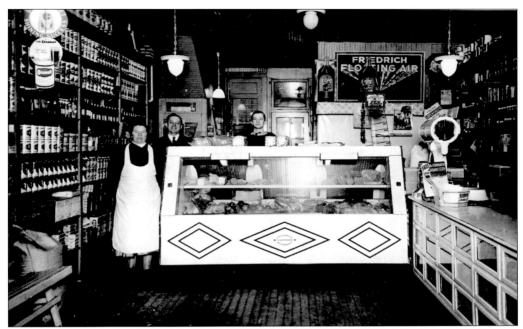

The small family-owned groceries operated "on the books." Customers received credit between paydays. In the 1930s, most of Chicopee's mills were closed. Agatha and Felix Jendrysik, pictured with their son Stephen, managed to keep their business open until 1938. That year, a giant flood wiped out the grocery business.

Ignacy Partyka actually served in the Polish army before he emigrated to America in the 1920s. He was sponsored by his brothers. The Partykas were from Kamien, a small rocky village near Rzeszow. In Chicopee, the immigrants proudly referred to themselves as Kamienocs.

The Partyka brothers reportedly sent this picture to their relatives in Poland. It was a portent of things to come. Leo would own a Chevrolet dealership in Connecticut; Joseph started a successful resource-management business supplying timber for the Holyoke paper mills; Anthony for many years ran a grocery business in Holyoke; and Ignacy, the youngest brother, worked in the meatpacking industry before he established the Falls Provision Company in Chicopee Falls.

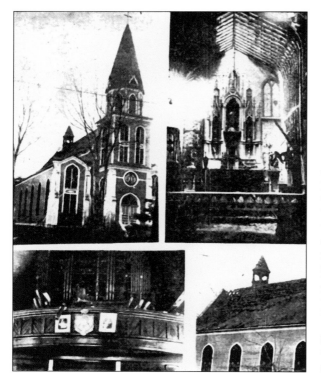

A fire of unknown origin destroyed portions of the sanctuary, roof, and pipe organ. A special meeting was held on April 9, 1933, where the parishioners of Holy Mother of the Rosary Parish made plans to repair the church. The rededication ritual was conducted by Bishop Francis Hodur, titular head of the Polish National Catholic Church in America. At the October 29, 1933, ceremonies, Mayor Anthony J. Stonina was an honored guest. Six weeks later, the mayor would be out of office.

Five

POLISH PARTY
1934–1941

In 1934, there were 17 members of the Chicopee Board of Aldermen. According to local pundits, they were all planning a run for mayor. Two Polish aldermen were considered serious candidates. Aldermanic president Walter Grocki and young Chester Skibinski were organizing support for a city hall run. Approximately 35 percent of the city's registered voters were Polish, and they all voted. Quietly, A. J. Stonina began to woo uncommitted Irish voters.

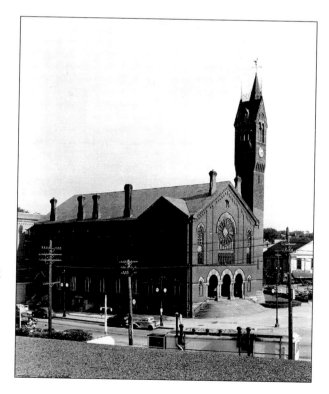

In Chicago in 1932, Franklin D. Roosevelt accepted his party's presidential nomination. The following year, the city hosted the World's Fair. That summer, the Polish Falcons of America held their national convention in Chicago. Chicopee Nest No. 855's delegation participated in the track-and-field events and visited the fair.

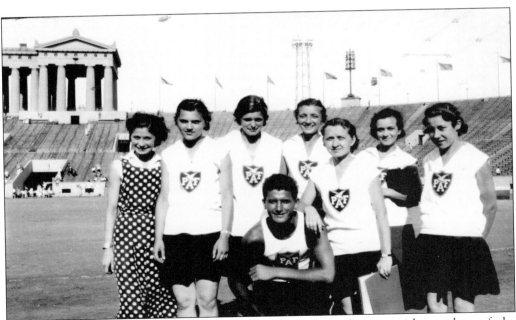

At Soldier's Field, Chet Baldyga (a medalist from Worcester) poses with members of the Chicopee delegation. On his right are Stephanie Przyblya and Alice Krzeminski. The young ladies would train three generations of Chicopee Falcons. Alice (Krzeminski) Murphy served as the organization's president for many years.

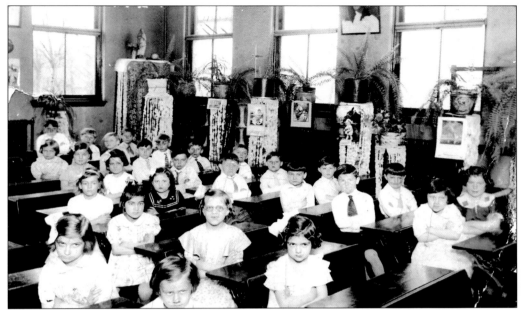

Parochial school was serious business for these first graders in 1933. At the fifth desk in the far row, Joseph Partyka Jr. and his desk mate Henry Skiba faced an uncertain future. From the pulpit, Fr. Lawrence Cyman urged all Polish youngsters to attend his school. The pastor was dismayed when students stayed only long enough to receive the sacraments.

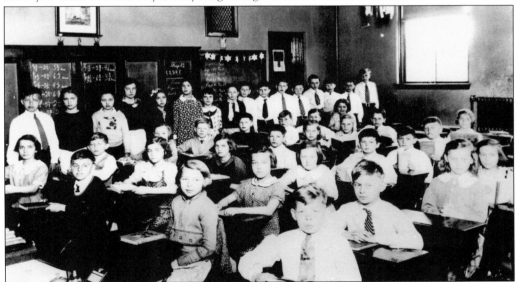

As this picture of grade five clearly illustrates, the very large classes at the St. Stanislaus Parochial School were a problem. The sisters who taught there had to be fluent in both Polish and English, since instruction was offered in Polish in the morning and English in the afternoon. Church historian Dr. Gladys Midura reports that the school was still using books published in the late 19th century. Wanda Dominik (née Kudla), in the last seat of the far row, identifies Chicopee Comprehensive High School principal Mitchell S. Kuzdzal as the young man in the second seat of the far row.

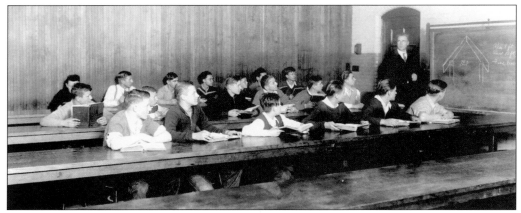

During the 1930s, Chicopee High School served students in grades 10 through 12. St. Stanislaus School had a ninth-grade class. Upon graduation, a majority of the young men enrolled in the vocational program at the high school, pictured above. High school teachers urged the young Polish women to take clerical courses. During the difficult Depression years, many promising students quit school to go to work.

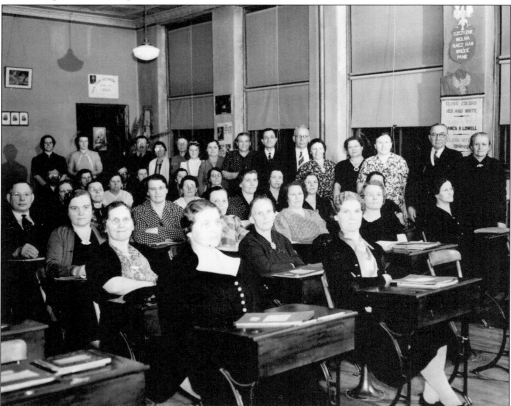

In the politically turbulent years of the 1930s, Father Cyman urged the parish's adult population to attend citizenship classes. Realistically, this added to the Polish vote on election day. Teacher Emilia Bielski (née Czelusniak), standing first on the left near the back wall, praised her students for their hard work and dedication.

In Chicopee, the Cyran sisters were the city's first Polish American educators. In 1928, Ann (right) graduated from Fitchburg State College and was hired to teach first grade at the Spruce Street School. The following year, Victoria (left), a graduate of Westfield State College, started her career teaching fourth grade at the Belcher School. The young ladies paused for a picture before embarking on a trip to Europe in 1935.

Compliments of

Val's Hotel

Chicopee's Most Friendly Hotel

VAL BALUT, Manager

TEL. 8258 50 WEST STREET

A. J. STONINA & F. J. TABAKA

67-69 EXCHANGE STREET CHICOPEE, MASS.

TELEPHONE 887

Dealers in

HUDSON—TERRAPLANE—LASALLE—CADILLAC
BUICK AND OLDSMOBILE AND GMC TRUCKS

Kendall House Hotel

Beer—Wines—Liquors

DINE and DANCE

MARKET SQUARE TEL. 55 CHICOPEE, MASS.

During his brief retirement from public office, Stonina and his half-brother F. J. Tabaka became the first dealership in the region to offer five General Motors brands. In 1935, Prohibition was over and the liquor interests were major players in local elections. On December 3, 1935, A. J. Stonina received 6,497 votes to 6,106 for incumbent mayor Oneil Deroy. The mayor and his supporters staged a massive victory parade. His victory was complete; the Polish Party now had a solid majority on the board of aldermen.

Polish American Veterans Post 168 was composed of Polish and American army veterans. In 1935, while internal strife continued, Poles around the world listened to ominous sounds emanating from their traditional enemies, Germany and Russia. In 1936, the post purchased the stately former home of the agent for the Dwight Mills. The building at 116 School Street would serve as quarters for several Polish organizations.

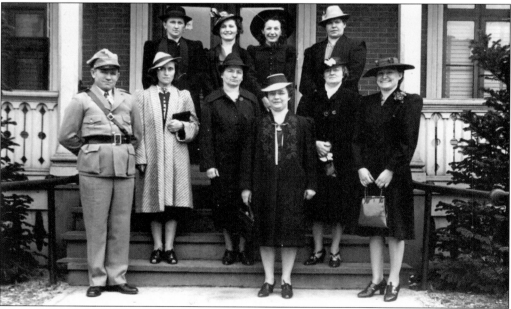

Post 168 commander Andrew Pinciak is pictured here with the Polish Army Veterans Auxiliary. Initially the ladies were responsible for the organization's social events. As the situation in the fatherland deteriorated, the auxiliary spearheaded local Polish relief efforts. In 1936, there were 20 Polish civic organizations actively seeking a public identity that would reflect its members' contributions to and interest in the American society they had become a part of.

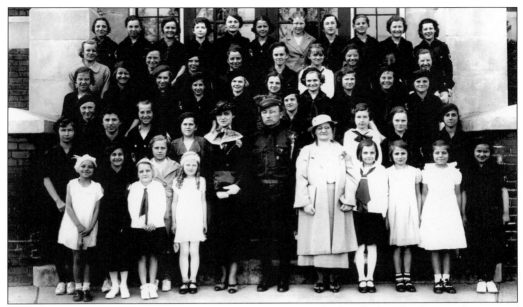

Young members of the Polish National Alliance, photographed with their leaders on the steps of St. Stanislaus School, were members of the largest ethnic fraternal benefit society in the United States. The society was founded in Philadelphia, Pennsylvania, on February 15, 1880. In the 1930s, the Polish National Congress lobbied the U.S. Congress on behalf of Polish Americans.

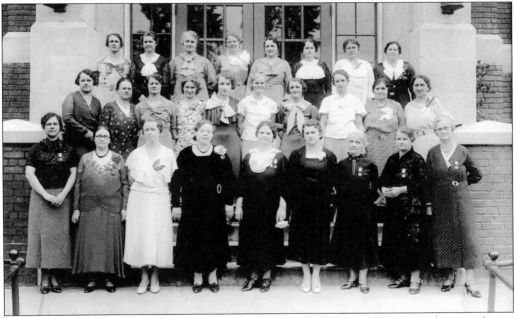

The Kolko Polek (Polish Women's Circle) was formed in 1917 to aid the Polish army during World War I. In 1936, the organization began raising funds for Polish refugees. The Kolko Polek meetings were always conducted in Polish. The society continued to support children's hospitals in Poland. During the difficult Depression years, the ladies provided direct aid to the most needy parish families.

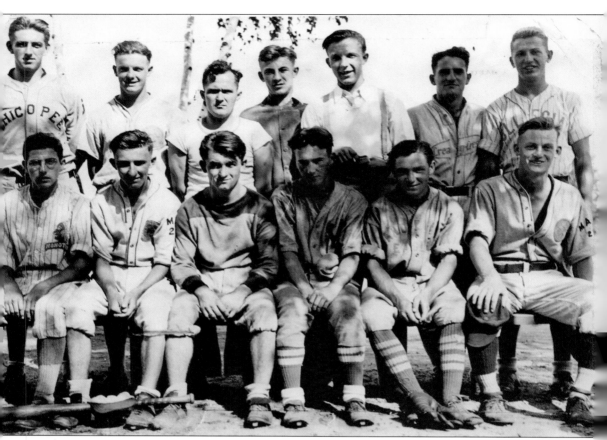

The Dana AA park league baseball team is shown in a photograph from 1931. Bronislaw J. "Bones" Stepczyk is shown seated at right. The Stepczyk family lived on Hampden Street, and all three brothers played for the Dana AA. In the 1930s, the Danas were a powerhouse junior athletic program, winning many city championships. Unfortunately, many of the best players went to play for Cathedral High School in Springfield. Bones Stepczyk played for the hometown team. Serving at Chicopee High School from 1932 to 1935, Stepczyk excelled in baseball and football. He was chosen three times on all western Massachusetts schoolboy baseball and football teams. He graduated in 1935 as vice president of his class. He spent a year at Williston Academy in Easthampton, setting records in baseball, football, and hockey.

Bronislaw J. Stepczyk (left), co-captain with Louis Duesling (right) of the Brown University football team, is shown in this photograph from 1941. Stepczyk graduated in June 1942. He joined the U.S. Army Air Corps and was assigned to Maxwell Field in Alabama as an aviation cadet. First Lieutenant Stepczyk was assigned to the Far Eastern theater, flying troops over the famous "hump" between Burma and China. He was killed in the closing days of the war and is buried in Arlington National Cemetery.

For the most part in the 1930s, the children of the immigrant Poles did not finish high school. For some there would be jobs in the Works Progress Administration (WPA) and in the Public Works Administration (PWA). Many Polish youngsters became members of the Civilian Conservation Corps (CCC). Edward Polchlopek (first on right) is pictured here at a camp in Madison, Connecticut.

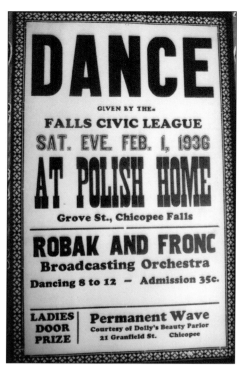

All across America, from the mid-1930s to the mid-1940s, the big bands were king. In Chicopee, the Butterfly Ballroom at the Polish National Home on Center Street was the place to be on Saturday night. In the Falls, young people danced in the huge Crystal Ballroom of the Polish Home on Grove Street. While none of the national bands ever played in Chicopee, old-timers argue that the talented Robak and Fronc Orchestra was just as good.

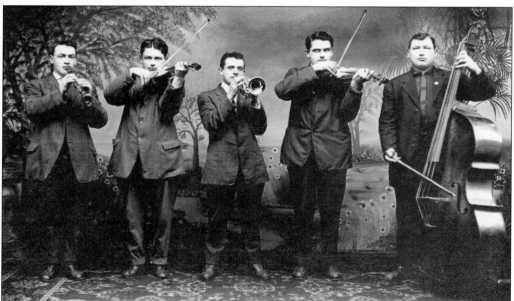

In the 1920s, Jan Robak (with violin on the left) began playing professionally while working in the meatpacking industry. In the 1930s, he teamed with Walter Fronc and began playing in Polish halls all over western Massachusetts and northern Connecticut. A Springfield appliance store owner named Jan Kasko hosted a live polka music broadcast from the Stonehaven Hotel in Springfield. Robak and Fronc played at the Stonehaven Hotel and were recording for two national record labels.

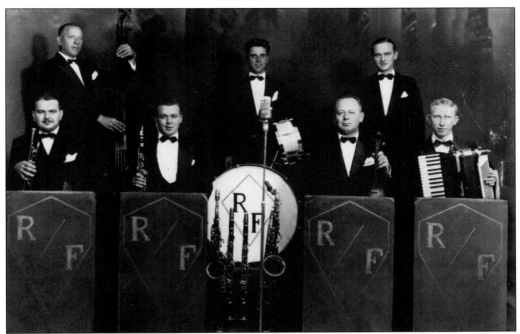

By 1937, the local employment situation improved. Young people could afford the modest admission price. The halls were jammed as the Merry Cavaliers, Melody Kings, Silver Bells, and Robak and Fronc played popular dance music along with the polkas, obereks, and romantically nostalgic waltzes. From left to right are (first row) Stanley Kusiak, Frederick Robak, Jan Robak, and Frank Sumowski; (second row) Walter Fronc, Fred Wozniak, and Mac Bobala.

Polish-American Dance

SPONSORED BY
THE BEMIS ESQUIRES

Saturday Evening, October 5, 1940

AT POLISH HOME AUDITORIUM
Cor. Grove & Market Sts. Chicopee Falls, Mass.

MUSIC BY
Robak & Fronc Orchestra.

Dancing 8 to 12. Admission 35c - Incl. Tax

The Bemis Esquires were from a place they called Bemisuwka. The property was located at Bemis Pond between Chicopee Falls and Chicopee Center. In the 1930s, baseball and football fields were carved out on the plains above the pond. For $100 per year, the brush was cleared and a baseball diamond was constructed along with temporary bleachers. The park served as the home field for the Chicopee Falls Polish Americans, one of the Depression era's best teams.

Bemisuwka, in the heart of a predominantly Polish neighborhood, was a truly magical place. The first-generation children referred to the place as Shangri-La, a remote, beautiful, imaginary place where life approaches perfection. Relaxing on Bemis Hill and dressed in their Sunday best are, from left to right, the following: (first row) Ted Pasternak, Fred Wegrzyn, and Rudy Kagan; (second row) Water Wrzesien and Joe Godek.

The clergy and laity of the Polish National Catholic faith gathered for an all-day program in observance of the installation of the cornerstone of the new parish center. One month later, on Sunday, October 24, 1937, in the new hall, they welcomed over 500 persons as the first Polish National Catholic church established in New England celebrated its 40th anniversary.

Chicopee High School graduate Frank D. Korkosz is pictured here with the planetarium projector he devised for the Museum of Natural History in Springfield, Massachusetts. He and his brother Stanley did most of the mechanical work themselves. The facility was dedicated on November 2, 1937. The cost of the homemade planetarium was less than $12,000. That was a tenth the cost of imported projectors.

On March 9, 1936, the Stonina administration began the construction of a city infirmary. The mayor indicated that he planned to use local tradesmen and welfare recipients on the federally funded WPA project. In 1937, upon completion of the building, it was announced that over 300 workers were employed during construction. The new building contained 50 rooms with a housing capacity for 150 inmates and cost $153,140. Of this amount, the federal government reimbursed the city $103,704.

Anne and Stephen Jendrysik were members of the Congress of Industrial Organizations (CIO). In 1937, they were the first members of their family to have a honeymoon. The bus trip to Washington, D.C., was a must for the two Roosevelt Democrats. Increasingly, first generation working-class Poles were defecting from the Republican party. Mayor Anthony J. Stonina, a Republican, was running for reelection. Ironically most of his young supporters were registered Democrats.

In November 1937, A. J. Stonina was engaged in a bruising reelection campaign. The mayor was under intense criticism within the Polish community. On Sunday nights, 50 million Americans tuned in to political commentator Walter Winchell's weekly broadcast. One Sunday night, Winchell was reporting on the politics of nationality in the city of Chicago but noted in passing that the Chicago crowd could take lessons from a little mill town in Massachusetts, certainly a dubious distinction for A. J. Stonina and his Polish American combine.

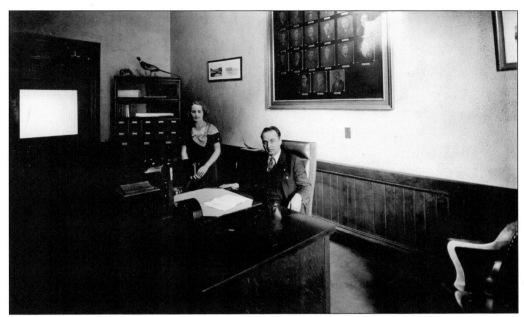

When the votes were counted, the mayor had been reelected. Photographed in his city hall office with his longtime secretary Helen Robak, the dapper mayor was as confident as ever. Unfortunately, in the brutal arena of ethnic politics, rumors clouded his narrow margin of victory at the polls. Charges of election fraud were followed by the mayor's announcement that he was leaving on a three-month vacation trip to his native land of Poland.

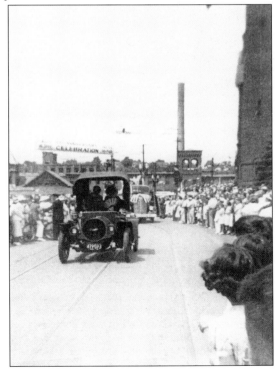

On Fourth of July weekend in 1938, the acting mayor sanctioned a 300th anniversary celebration of the founding of Chicopee. Unfortunately, it was 20 years too soon. In 1638, Native Americans were the only residents of Chicopee. A few days after the giant parade, French Canadian activists spread rumors of financial improprieties by parade officials.

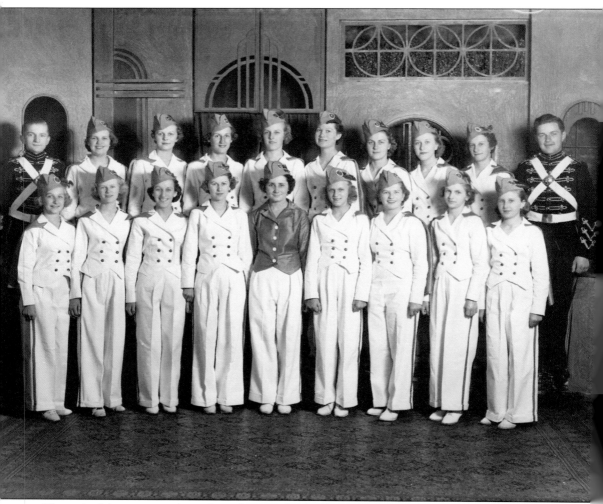

The colorful street parade took an hour and a half to pass the reviewing stand at city hall. Hundreds of marchers, 30 bands and drum corps, several from Connecticut, participated in the march along a seven-mile course. The newspaper noted that the largest float featured children from St. Stanislaus School attired in their bright native costumes. The group that drew the largest applause is pictured here. Polish Falcon Nest No. 855's crack drill team represented the city in parades all over New England. When the mayor returned from Poland, he covered the parade committee's unpaid bills.

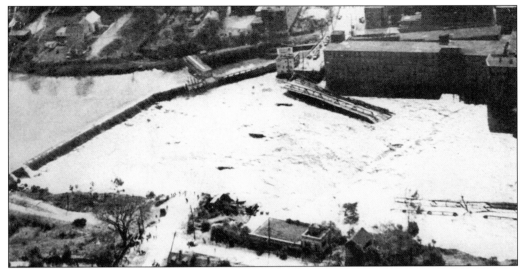

The Hurricane of 1938 was an event of truly historic proportions for the citizens of the Pioneer Valley. When the storm struck, the city was building a $2 million flood-control project in Willimansett. The flood washed out the Chicopee Falls bridge, leaving the lower floors of the Chicopee Manufacturing Company and the Fisk Company under 10 feet of water. Within weeks, the state would announce the construction of a new bridge in Chicopee Falls.

In 1926, alderman Tony Stonina took his first airplane ride over the Connecticut Valley. At the next meeting of the board of aldermen, Stonina made his first sales pitch for an airport on the North-South Highway. The mayor rejected the idea as too expensive. In 1938, Congress passed the Wilcox Act, authorizing a northeastern site for an air base. On November 22, 1938, two days after receiving the news, the telegram to the War Department indicated Chicopee was interested in the site selection process.

Ted Szetela was the young editor of the *Chicopee Herald* and the administration's ghostwriter. The editor worked closely with the aviation committee and helped write the mayor's presentation for his interview with Gen. H. H. "Hap" Arnold, chief of the U.S. Army Air Corps. According to local legend, the mayor was nervous and started off by addressing the general, "Well, if you look at this map, Captain. . . ."

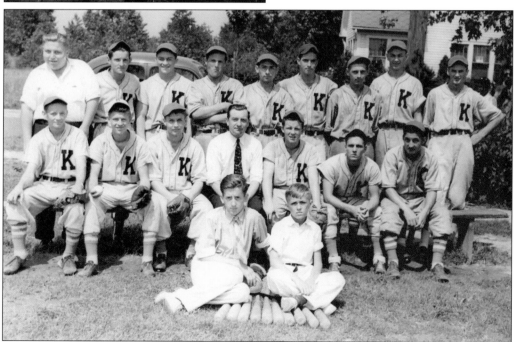

In 1939, Chicopee's boys of summer competed for the coveted city league championship. One of the best, Kozikowski's AC, is pictured here. Included in the photograph are bat boys Andy Mitera and Max Watras, Stan Kusek, Vincent Korzeniowski, Stanley Szwedzinski, Dominick Kozikowski, team sponsor Stanley Szwedzinski, Alfred Lewandowski, manager Ted Drewniak, Jerry Partyka, John Ryan, Corky Czelusniak, Edmund Kozikowski, Gabby Kida, and Andy Czelusniak.

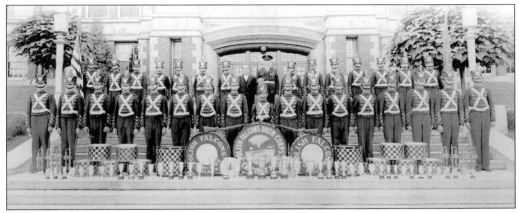

The young men of the Polish Falcon Drum and Bugle Corps in 1939 were celebrating their 10th anniversary. Here on the steps of Chicopee High School, the corps takes time to exhibit the trophies won in competition. The group frequently appeared at the mayor's political gatherings.

At a sporting event in an election year, candidates never miss a photograph opportunity. In 1939, the mayor was in trouble. The combined Franco-American political organizations were all supporting the same candidate. He is pictured here with popular Republican state senator Chester Skibinski (second from the right).

At Flushing Meadows, Queens, on April 30, 1939, at 3:12 in the afternoon, Pres. Franklin D. Roosevelt officially opened the New York World's Fair. Sixty foreign governments were represented at the fair. Virtually every major industrial nation save Germany had buildings along the Lagoon of Nations. Pictured here, the small but impressive Polish Pavilion was dwarfed by the massive exhibit of the Soviet Union. The building featured a 190-foot Karelian marble pillar topped by a 79-foot steel figure of a Soviet worker holding aloft a lighted red star.

The fair was called the World of Tomorrow. Few among the tens of millions of Americans who experienced the New York World's Fair of 1939–1940 have been able to forget it. Fifty years later, the exposition remains unsurpassed in its imaginative vision of the future. Pictured here at the fair are, from left to right, Louise Ciszek, Bertha Sudyka, and Frances Rusin.

Despite the fact that it took six hours round-trip by automobile, Chicopee's Polish Americans visited the fair in record numbers. John and Helen Stachowicz, the exhausted young couple pictured here, were able to visit the Polish exhibit in the summer of 1939. On Labor Day weekend, the Polish Pavilion was closed following Germany's unprovoked attack on the Polish nation.

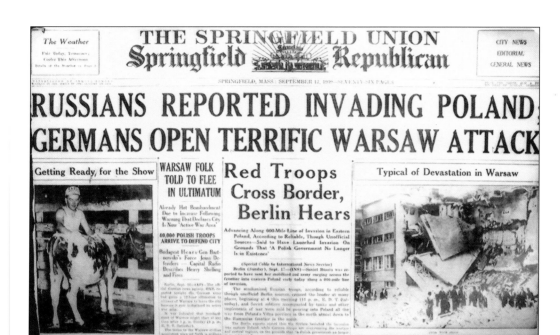

THE SPRINGFIELD UNION
Springfield Republican

CITY NEWS
EDITORIAL
GENERAL NEWS

SPRINGFIELD, MASS., SEPTEMBER 17, 1939—SEVENTY-SIX PAGES

RUSSIANS REPORTED INVADING POLAND GERMANS OPEN TERRIFIC WARSAW ATTACK

Getting Ready, for the Show

WARSAW FOLK TOLD TO FLEE IN ULTIMATUM

Already Hot Bombardment Due to Increase Following Warning That Declares City Is Now 'Active War Area'

40,000 POLISH TROOPS ARRIVE TO DEFEND CITY

Budapest Hears Gen Bartnowski's Force Joins Defenders — Capital Radio Describes Heavy Shelling and Fires

Red Troops Cross Border, Berlin Hears

Advancing Along 600-Mile Line of Invasion in Eastern Poland, According to Reliable, Though Unofficial Sources—Said to Have Launched Invasion On Grounds That 'A Polish Government No Longer Is in Existence'

Typical of Devastation in Warsaw

After Germany annexed Austria and the largest section of Czechoslovakia late in the 1930s, Poland's position became extremely fragile. When on August 23, 1939, Hitler and Stalin completed a nonaggression pact that included a secret clause dividing Poland into Soviet spheres. This "fourth partition of Poland" was the decisive factor leading to the global confrontation that became known as World War II.

Mayor Anthony J. Stonina was sitting at his desk wiping away tears. On September 19, 1939, he had just finished reading the brief War Department letter. The seven square miles of Chicopee's Tobacco Plains had been selected as the site for the new Northeast base of the U.S. Army Air Corps. Aviation Committee member Ted Szetela (third from the right) leads a government team inspecting the site.

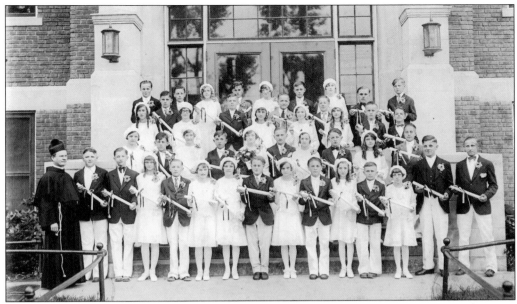

For the large Polish American congregation at St. Stanislaus Parish on Front Street, the news from Poland was met with dread and apprehension. Rev. Lawrence Cyman, their respected pastor, was in close contact with the Catholic Church in Poland. In 1939, Father Cyman was elected minister provincial of the Franciscan St. Anthony of Padua Province. Here he is pictured with the graduates of the St. Stanislaus Parochial School.

Chicopee's most famous Polish American citizen in 1939 was seven-year-old Sylvia Zaremba. She began playing the piano at the age of five and, according to her parents, had never been forced to play. Here she is greeted by Governor Saltonstall of Massachusetts. At the age of 11, she awed a Cleveland audience of 5,000 by playing a Mozart concerto. The following year, she played with the Philadelphia Orchestra and the New York Philharmonic.

In 1932, Wicenty Partyka, the father of four young children, was killed when he fell from a truck. During the Depression years, his widow, the extraordinary woman pictured here, ran the family milk business while bringing up her children. Always well dressed, Katryna Partyka is making a milk delivery on Perkins Street.

On Saturday afternoon, October 15, 1939, the city dedicated a new park on Front Street. Frank J. Szot was the first Chicopee soldier killed in World War I. Szot Memorial Park was named to honor his sacrifice. Pictured here are members of the Szot family who were honored guests at the ceremonies.

The audience held its breath as the guns were fired. The damp, cloudy day fit the times, especially for Chicopee's Polish Americans whose homeland had fallen to Hitler and Stalin in the closing days of September. With the dedication of the Szot Memorial Park Fountain, the events of the day honored the heroes of the last war, while the speeches confirmed the looming specter of another war.

The federation of the Combined Polish American Clubs was headquartered at the Chicopee Falls Polish Home on Grove Street. According to local legend, the huge crowd that showed up to cheer Mayor Stonina's 1937 election triumph were so closely packed into the hall they were unable to clap—instead, the mob literally jumped for joy. In 1939, bartenders (from left to right) Ludwik Garczynski, Emil Pirog, and Joseph Pasternak were ready, but the crowd never showed up.

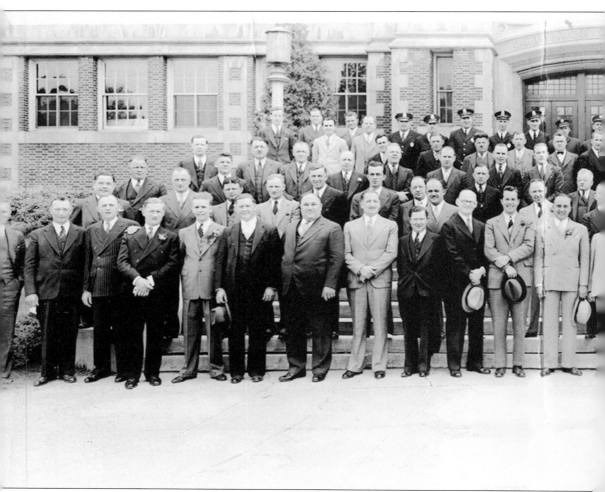

Before the municipal election, the members of Mayor Stonina's administration had their picture taken for the last time in 1939. The aura of success on the surface was superficial. The Polish American combine had come apart at the seams. In 1939, the Poles made up 40 percent of the population, but a string of defections, political infighting, and a spate of corruption scandals generally laid at the mayor's doorstep had dulled most of the administration's solid accomplishments. The Committee to Re-Elect A. J. Stonina highlighted Westover Field as the hope for the city's future. Unfortunately, the electorate had mixed emotions about the new base.

The mayor's fate was sealed when the Franco-Americans united in their support for Leo Senecal, the chairman of the Chicopee Board of Assessors. Stonina's run ended on Tuesday evening, December 5, 1939. A huge crowd was in front of the Hastings stationery store in Market Square as the election returns were posted. The early returns from the Polish wards drew gasps from the audience. The incumbent was winning, but his margins would not hold up across the city. Senecal's margin of victory would be the largest in the history of the city.

On October 19, 1941, a banquet honored Fr. Lawrence Cyman, who was celebrating two milestones: 35 years as a priest and the last 25 as the spiritual leader of St. Stanislaus Parish. Three weeks later, on November 9, 1941, Bishop Thomas O'Leary of the Springfield Diocese celebrated a Thanksgiving mass in commemoration of the golden anniversary of the founding of St. Stanislaus Church.

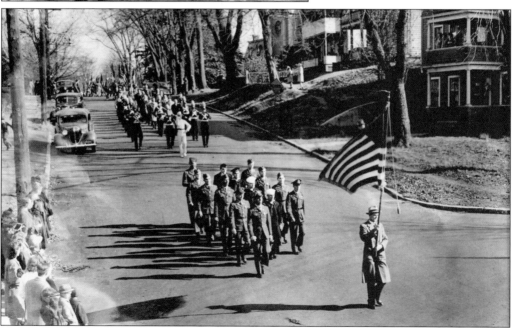

The United States entered World War II on December 8, 1941. There is nothing more sacred to a person of Polish ancestry than the Wigilia, or traditional Christmas Eve celebration. In 1941, in homes all over the old mill town, families shared Oplatek, the sacred wafer wishing good fortune and good health to all present. Three thousand of these young Polish men and women were about to serve their nation. Stanley Pietras carries the flag during a wartime parade on South Street.